IMAGES
of America

SEAL BEACH

Dedicated to my grandchildren Mark, Krislyn, and Lacey, and all who love Seal Beach and believe our city's history should be preserved for future generations.

IMAGES
of America

SEAL BEACH

Laura L. Alioto

ARCADIA
PUBLISHING

Published by Arcadia Publishing
Charleston SC, Chicago IL, Portsmouth NH, San Francisco CA

Printed in the United States of America

Library of Congress Catalog Card Number: 2005920113

For all general information contact Arcadia Publishing at:
Telephone 843-853-2070
Fax 843-853-0044
E-mail sales@arcadiapublishing.com
For customer service and orders:
Toll-Free 1-888-313-2665

Visit us on the Internet at www.arcadiapublishing.com

CONTENTS

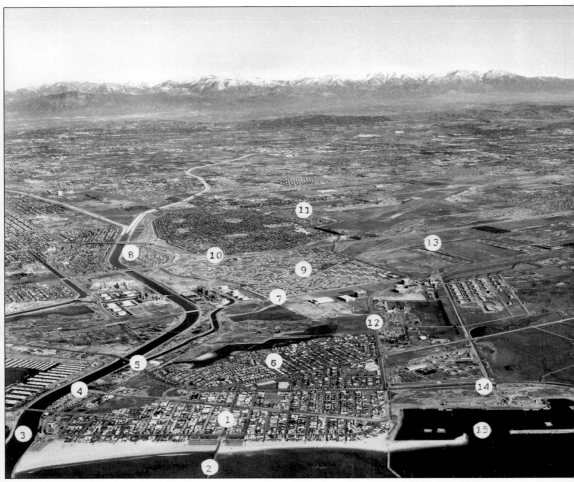

This 1967 aerial view shows how the city of Seal Beach is divided into areas by major highways and a freeway: Old Town (1), Pier (2), San Gabriel River (3), original location of the trailer park, moved northward in the 1970s (4), Pacific Coast Highway (5), the Hill (6), Westminster Boulevard (7), College Park West (8), Leisure World (9), 405 Freeway (10), College Park East (11), Seal Beach Boulevard (12), Naval Weapons Station (13), Wildlife Refuge (14), Anaheim Bay (15), and Surfside (16).

INTRODUCTION

The Gabrielino-Tongva Indians were in the Seal Beach area as long ago as 2,000 years. These good-natured people gathered mussels and clams from the seashore and ground acorns for flour. Their life changed as the Spanish—and later the Mexicans—established ranchos. Seal Beach was part of the Rancho Los Alamitos.

German immigrants bought a parcel of land from the Rancho Los Alamitos, which they called Anaheim. Needing a place on the coast to ship their produce, wine, and wool, they established a small port and called it Anaheim Landing and Bay. In the summer, wagon trains carried their exports to Anaheim Landing where they could trade with the sailing vessels bringing lumber and supplies from San Francisco. Their families came along to escape the inland heat. They lived in tents and flimsy shacks. Years passed before they built sturdier cottages and their little community was renamed Bay City.

The Hellman and Bixby families purchased the Rancho Los Alamitos and established large ranches. Philip A. Stanton purchased their section of coastal land between Anaheim Landing and the San Gabriel River. He used the name Bay City for his purchase, and with a partner he founded the Bayside Land Co. to sell real estate.

In 1904, the Pacific Electric Railway began running Red Cars throughout Orange County. This made Bay City accessible for visitors and real estate buyers. Stanton received permission from the State legislature to incorporate Bay City. Incorporation was approved October 1915, but with the name Seal Beach to stop the confusion with San Francisco which was also known as Bay City.

To encourage more visitors to Seal Beach, Stanton established the Joy Zone. The pier was rebuilt, and the rollercoaster that had been at the 1915 San Francisco Exposition was shipped to Seal Beach. Two pavilions were constructed at the entrance to the pier. Intrepid daredevils put on exhibitions with a stunt plane and hot air balloon. The Red Cars brought in 20,000 visitors a week. Subdivision and house-building continued apace. The Great Depression of the 1930s put the Joy Zone out of business, but delightful little Seal Beach continued to grow.

Today, Seal Beach has a population of approximately 26,000 people. The city covers a large area divided by highways and freeways, and the sprawling nature of its growth has made it necessary for the various parts of Seal Beach to develop their own unique traditions.

Seal Beach depicts the city's fascinating history as captured by the lens of the camera.

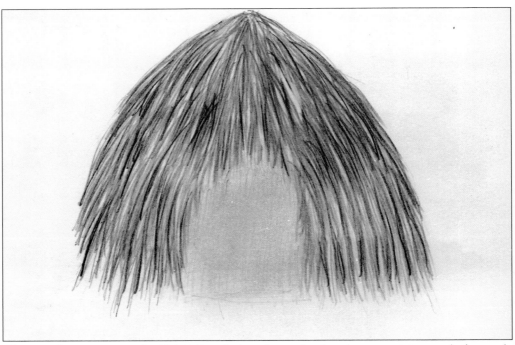

This artist's conception of a Gabrielino shelter shows the thatch construction made from tule (rush and reed). The tule grew along the banks of the rivers. The Gabrielinos also made baskets, water carriers, footwear, and aprons from the tule. (Courtesy SBH&CS.)

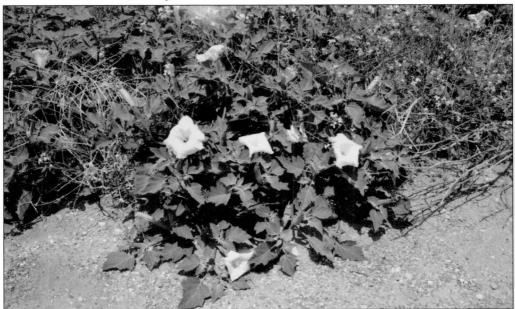

Bioswale is vegetation that contains human and other animal remains. The main component of the bioswale on the Hellman Ranch is sagebrush, pictured on the upper right side. The plant in the foreground is jimson weed, which is hallucinogenic. The Gabrielino-Tongva Indians used the jimson weed in a ceremonial drink. (Courtesy William Ward.)

One

THE ORIGINAL
INHABITANTS

By studying artifacts found in strata and using carbon dating, archeologists learned that Indians inhabited Southern California as far back as 8,000 to 10,000 years ago.

The history of the Gabrielino tribe (named after the San Gabriel Mission) traces back 2,000 years. In the late 1950s, when part of the Hellman Ranch was developed into the Marina Hill homes project, many artifacts were recovered. Innumerable grinding stones have been found. Near the San Gabriel River, a human skull found in 1960 was carbon-dated at 1,000.

The Gabrielinos were of Shoshonean stock. They ate fish, seals, mollusks, berries, reptiles, and grasshoppers; trapped small animals; and made flour out of acorns. From tule (rush and reed), they built shelters, footwear, hats, water carriers, and aprons.

The political unit was the tribelet of 3 to 30 neighboring villages. The leader lived in the largest village and "spoke with wisdom." Pungva, a large Gabrielino village, overlooked the San Gabriel River and was located on the site of the Rancho Los Alamitos.

Descendants of the Gabrielinos in this area are identified as the Gabrielino-Tongva. During recent excavation on the Hellman Ranch, members of the tribe were responsible for the oversight of the operations. Skeletal remains were placed in body bags and removed to a site designated as the Indian Cemetery.

An Interpretive Center is a circular concrete wall embedded with Indian grinding stones and topped with flagstone. Demonstration of Indian customs can be seen here. A retaining wall has bronze plaques that recognize important eras in Seal Beach history.

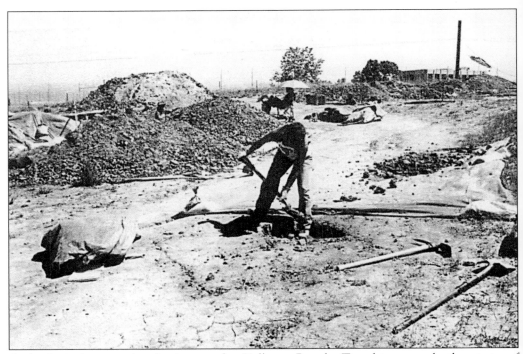

Archeological excavation begins on the Hellman Ranch. Trenching reveals the strata of the soil. Of special interest is stratum containing seashells, indicating habitation by Native Americans. (Courtesy William Ward.)

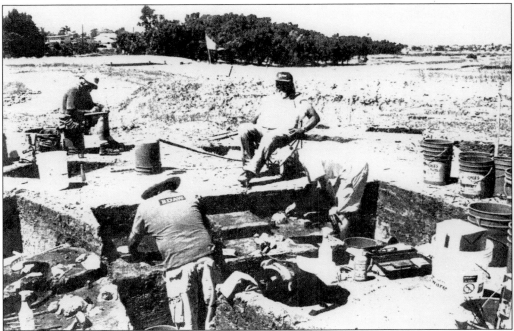

The workers shown here have found a promising stratum for artifacts. They use trowels at this stage to avoid damaging items of interest. (Courtesy William Ward.)

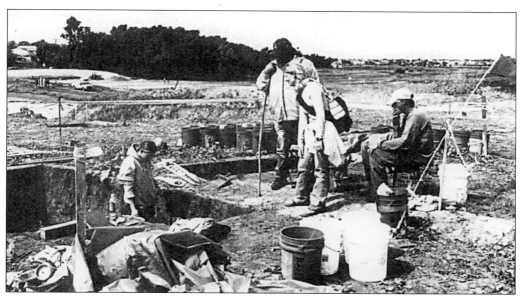

Pictured here is an examination of a trench. Each trench will be given a label for identification of its exact location. (Courtesy William Ward.)

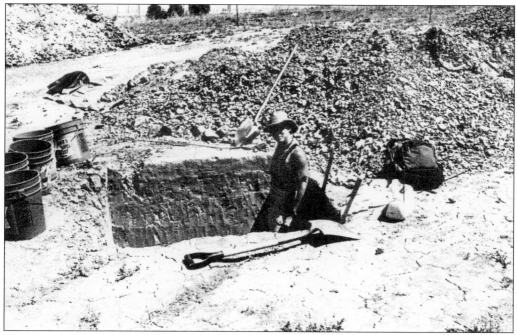

This trench reveals several layers of soil. A stratum that contains seashells is known as shell midden. (Courtesy William Ward.)

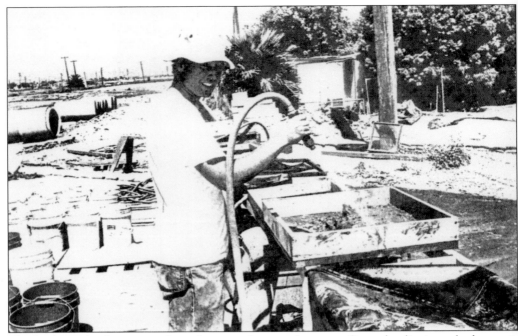

The buckets of soil are poured into boxes with screen bottoms. Once the dirt is washed away, it leaves shells, bone fragments, and artifacts intact. (Courtesy William Ward.)

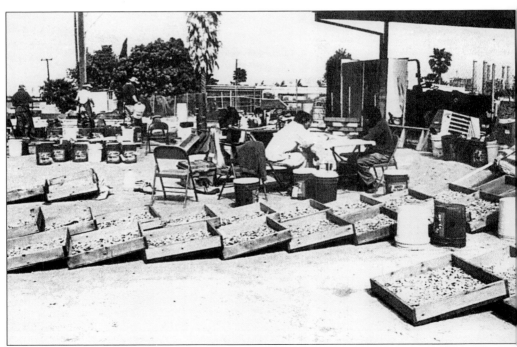

The screen boxes are staged or layered to facilitate airing and drying. (Courtesy William Ward.)

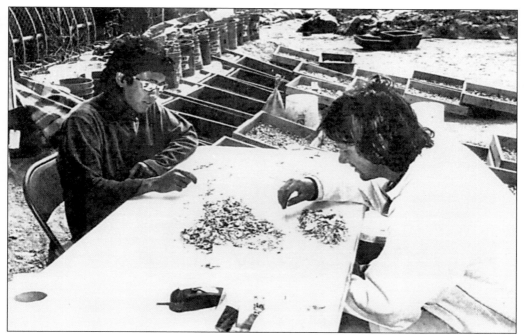

These two archeologists are sorting shells. They are looking specifically for bone fragments and artifacts. (Courtesy William Ward.)

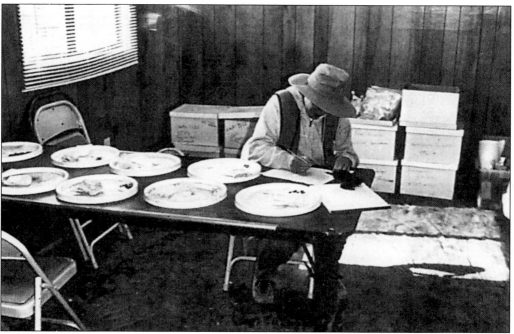

The archeologist is evaluating and cataloguing bone fragments. Each will be identified as to the type of bone and the location where it was found. (Courtesy William Ward.)

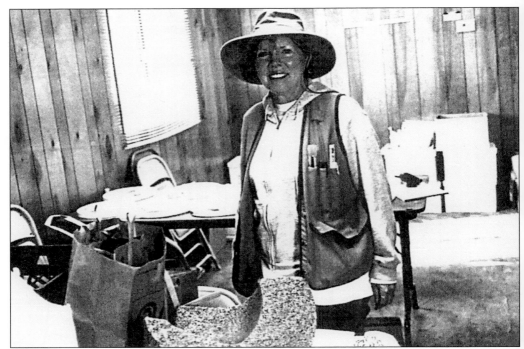

This archeologist is evaluating grinding stones found by William Ward in the 1960s on the Hellman Ranch. The stones were placed with the Seal Beach Historical and Cultural Society (SBH&CS) for safekeeping. Many of these stones are now embedded in the wall of the Indian Interpretive Center. (Courtesy William Ward.)

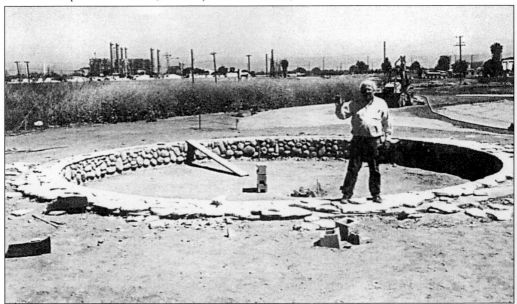

The Indian Interpretive Center can be used for demonstration of Native American customs. Speaking from the center of the circle gives a slight echo and the grinding stones give a "canyon echo" effect. (Courtesy William Ward.)

Two

ANAHEIM LANDING AND BAY

From the Rancho Los Alamitos, a 1,165-acre parcel of land was purchased by German immigrants who became known as German Burghers. They named their village Anaheim (meaning "home by the river").

By 1863, they needed an outlet for selling their produce, wine, and wool. They needed a harbor where ships could bring them building materials and supplies and in return carry out their products.

Their first port at Alamitos Bay was destroyed by flooding from the San Gabriel River. In 1867 they moved southeast and formed a port that became known as Anaheim Landing and Bay.

Wagon trains carried their produce, wine, and wool from Anaheim to Anaheim Landing 12 miles away. Families often went along to escape the inland heat. To exchange goods with the large sailing vessels from San Francisco that anchored farther out at sea, they used lighters that had a shallow draft. From the anchored sailing vessels, the lighters carried back lumber and other supplies to the Landing.

In those early years, no stores were located at the Landing. Fresh water was not readily available and makeshift shelters and tents were often flooded after high tide. However, the beach was an attraction for the children, and the quiet water in the bay was perfect for swimming. Trips by rowboat could go quite far inland by rowing in the slough, a muddy inlet.

In 1890, crude shelters were being replaced by cottages. The prosperity of the shipping at the Landing declined with the advent of the Southern Pacific Railroad. With the railroad, goods could be shipped over land. The Landing continued to be a vacation home in the summer and the warehouse that had been used for shipping was made into a bathhouse, or pavilion. These summer residents called their little community Bay City.

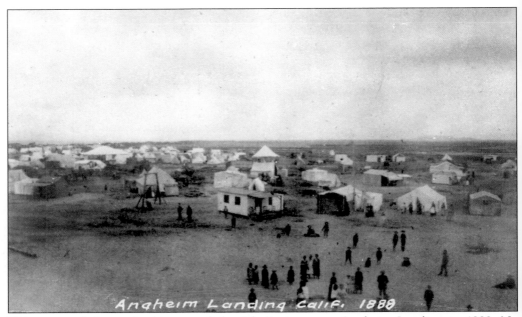

This postcard shows the bivouac of the 7th Regiment at Anaheim Landing in 1888. No stores were available and fresh water had to be transported from the San Gabriel River. (Courtesy SBH&CS.)

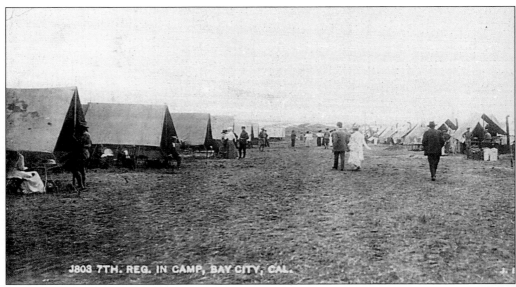

Pictured here is the 7th Regiment camp at Bay City. Visitors were allowed at the camp, as evidenced by this photo. (Courtesy SBH&CS.)

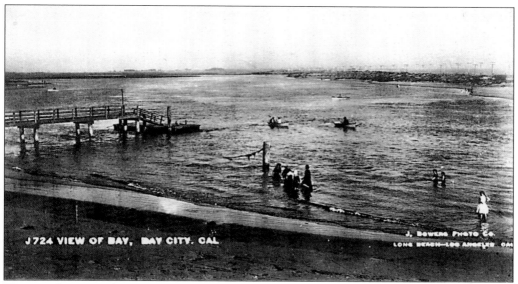

The people at Anaheim Landing called their community Bay City. The quiet water of the bay made swimming ideal. In the distance to the right, the power poles of the Pacific Electric Railway are visible. (Courtesy SBH&CS.)

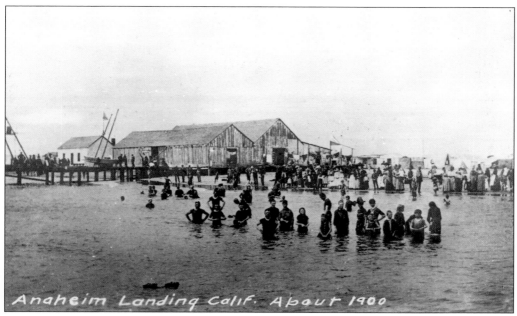

The people shown in this 1900 postcard were not permanent residents. They were vacationers seeking relief from the inland heat. The large building was the warehouse. (Courtesy SBH&CS.)

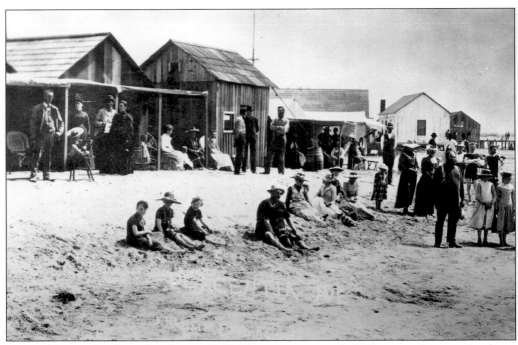

Pictured here is Anaheim Landing in 1900. The picture is entitled "Placentia Avenue, Anaheim Landing." (Courtesy First American Title.)

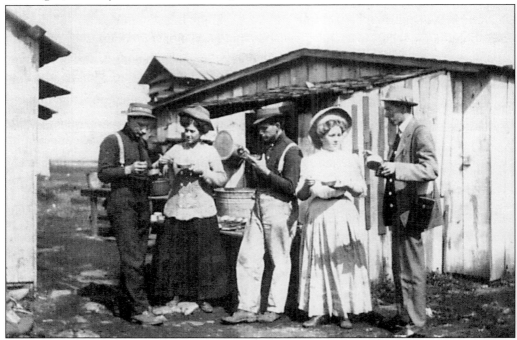

This 1910 photo shows five young people at Anaheim Landing with spoons and bowls. One wonders if they were eating clam chowder. By rowing through the estuary behind the landing, clams were easily dug up. (Courtesy SBH&CS.)

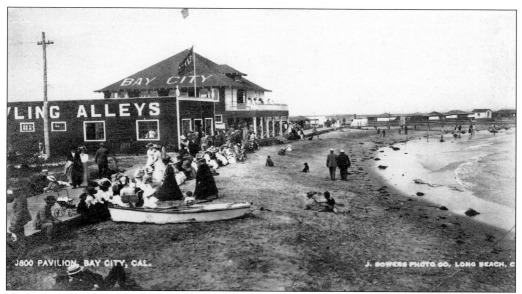

With the advent of the Southern Pacific Railroad, the Anaheim farmers were able to ship their goods over land. Business at Anaheim Landing declined. The warehouse was converted into a bathhouse, or pavilion. (Courtesy Clarence Pringle.)

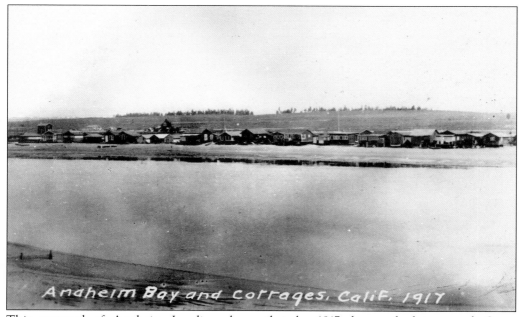

This postcard of Anaheim Landing shows that by 1917, houses had improved. Some residents were permanent and no longer just visitors. A plot of land (25 feet wide) was allotted to each house. This pattern became the basis for lots across the bridge in Seal Beach. (Courtesy SBH&CS.)

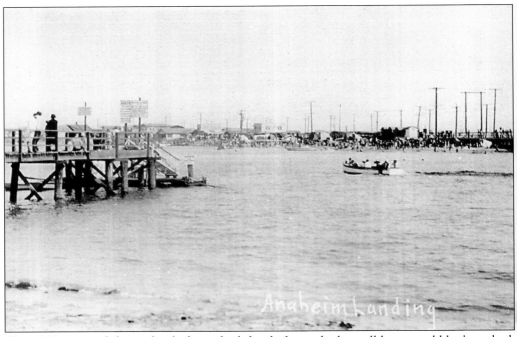

This 1920 postcard shows the dock on the left side from which small boats could be launched. The dock was also popular for diving into the Bay. The bridge and the Pacific Electric trestle are shown on the right side. (Courtesy SBH&CS.)

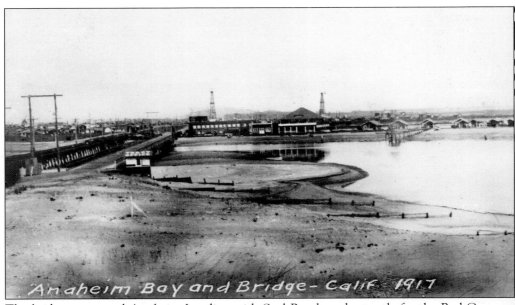

The bridge connected Anaheim Landing with Seal Beach and a trestle for the Red Cars was next to the bridge. Note the windmills in the background which drew up water from wells. (Courtesy SBH&CS.)

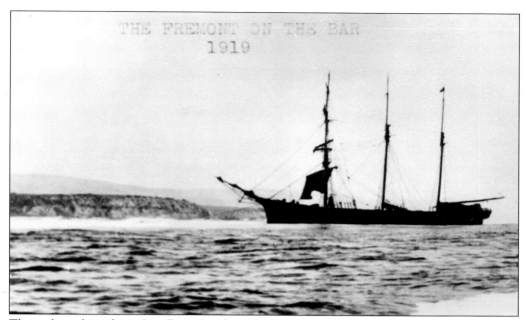

The sailing ships from San Francisco brought lumber and other supplies to trade with the Anaheim farmers. This picture is entitled "The Fremont on the Bar, 1919." This may mean that the ship was lodged on a sand bar and had to wait for high tide to be released. (Courtesy First American Title.)

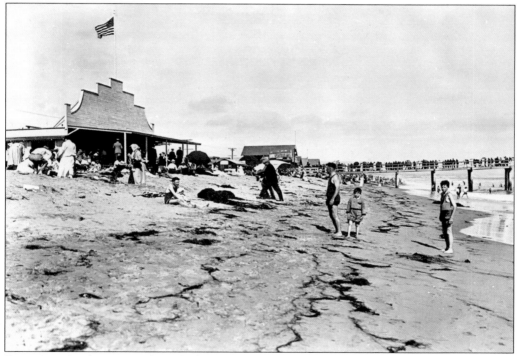

By 1920, Anaheim Landing had a general store with a post office. (Courtesy First American Title.)

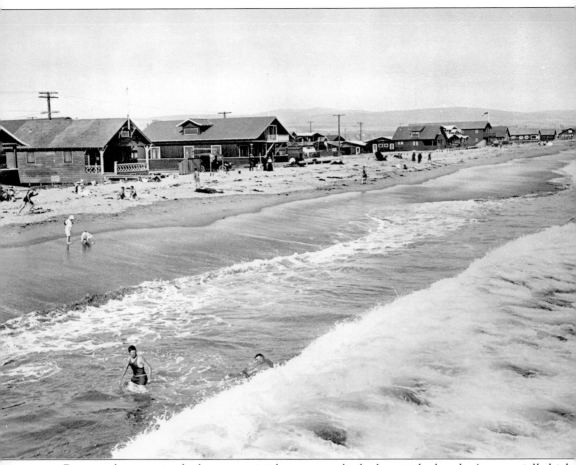

Because the water in the bay was quiet, houses were built close to the beach. An especially high tide, though, could reach the houses which is why some were built on stilts as can be seen under the house to the left. (Courtesy First American Title.)

Three

BAY CITY BECOMES SEAL BEACH

Philip Stanton bought a large parcel of land from the Hellman Ranch and a smaller parcel from the Bixby Ranch. Stanton, who became known as the "father of Seal Beach" as well as of Huntington Beach and the City of Stanton, sold a plot of land to John C. Ord in 1901. Ord, who owned a general store in Los Alamitos, hired teams totaling 30 mules to move his building to Bay City. He located his store on what is now the southwest corner of Main Street and Electric Avenue.

Ord became the first permanent resident in Bay City. Eventually, he also became first in these offices: judge, trustee, mayor, and postmaster. Ord formed the J.C. Ord Company with Stanton and Isaac Lothian as his partners. The Ord Company purchased property along the eastern edge of Anaheim Landing.

When Ord sold his shares of the company, Stanton and Lothian formed the Bayside Land Company in 1903. They began subdivisions. A 1913 map shows the subdivisions extending from First to Fourteenth Streets. Major newspapers carried advertisements for their real estate. Henry De Kruif drew the ads, which featured cute seals. In 1904, the Red Cars came to this city and made Bay City accessible to visitors and prospective real estate buyers.

Stanton's influence in the state legislature resulted in a vote to incorporate the city, but it had to be approved by the voters. Ninety-eight residents were eligible to vote and had to vote not only on incorporation but also upon a Board of Trustees. The vote for incorporation carried 84-14.

Only candidates who favored incorporation were elected to the board. John C. Ord was so highly regarded that he received all 98 votes. Formal incorporation occurred October 27, 1915. At that time, the name of Bay City was changed to Seal Beach. Changing the name eliminated the confusion with San Francisco, which was also known as Bay City.

I.W. Hellman was a partner in buying the Rancho Los Alamitos. This dwelling on the Hellman Ranch was one of the main homesteads. (SBH&CS.)

Pictured here is the main barn on the Hellman Ranch, known as the Old Red Barn. (Courtesy Jean B. Dorr.)

Philip A. Stanton was the "father" of Seal Beach, Huntington Beach, and the City of Stanton. He was also a partner in the Bayside Land Company. His 1910 bid for governor of California was unsuccessful. (Courtesy SBH&CS.)

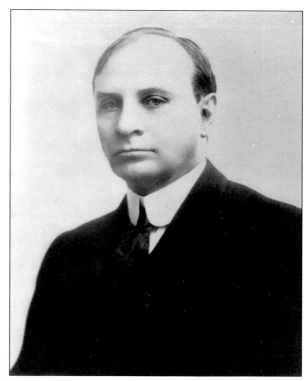

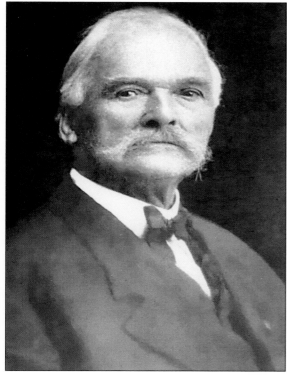

In 1901, John C. Ord became the first permanent resident in Seal Beach. He was also Seal Beach's first judge, postmaster, trustee, and mayor. (Courtesy SBH&CS.)

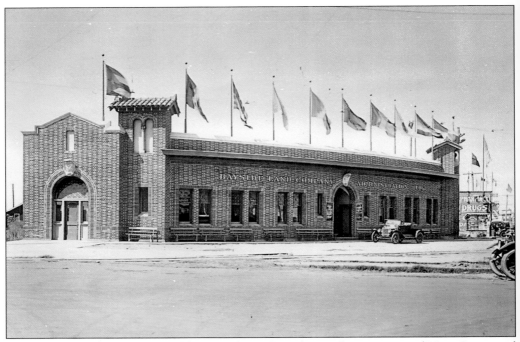

The Bayside Land Company building was located on the northwest corner of Main Street and Ocean Avenue. It was triangular in shape and was the turnaround for the Red Cars. A depot was also located in the building. (Courtesy First American Title.)

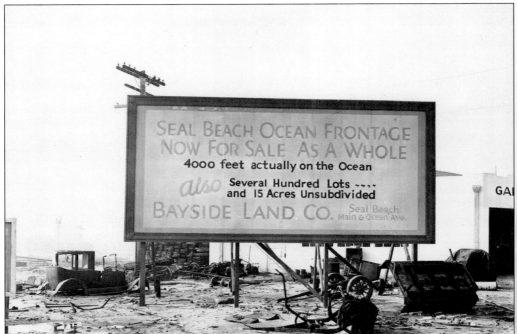

This 1932 Bayside Land Company sign was located on Tenth Street and Coast Highway. The company was owned by Philip A. Stanton and Isaac Lothian. (Courtesy SBH&CS.)

Henry De Kruif was an accomplished cartoonist who drew real estate ads for available property in Seal Beach. (Courtesy SBH&CS.)

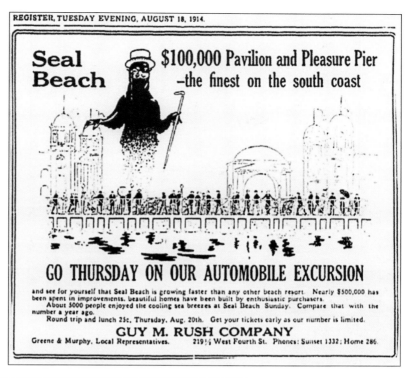

REGISTER, TUESDAY EVENING, AUGUST 18, 1914.

Seal Beach $100,000 Pavilion and Pleasure Pier —the finest on the south coast

GO THURSDAY ON OUR AUTOMOBILE EXCURSION

and see for yourself that Seal Beach is growing faster than any other beach resort. Nearly $500,000 has been spent in improvements, beautiful homes have been built by enthusiastic purchasers.

About 5000 people enjoyed the cooling sea breezes at Seal Beach Sunday. Compare that with the number a year ago.

Round trip and lunch 25c, Thursday, Aug. 20th. Get your tickets early as our number is limited.

GUY M. RUSH COMPANY

Greene & Murphy, Local Representatives. 219½ West Fourth St. Phones: Sunset 1332; Home 286.

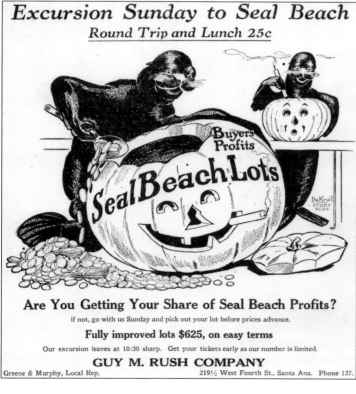

Excursion Sunday to Seal Beach
Round Trip and Lunch 25c

Buyers Profits

Seal Beach Lots

Are You Getting Your Share of Seal Beach Profits?

if not, go with us Sunday and pick out your lot before prices advance.

Fully improved lots $625, on easy terms

Our excursion leaves at 10:30 sharp. Get your tickets early as our number is limited.

GUY M. RUSH COMPANY

Greene & Murphy, Local Rep. 219½ West Fourth St., Santa Ana. Phone 137.

Henry De Kruif's ads always featured cute seals. The ads were carried by major newspapers in Los Angeles and Orange Counties. (Courtesy SBH&CS.)

27

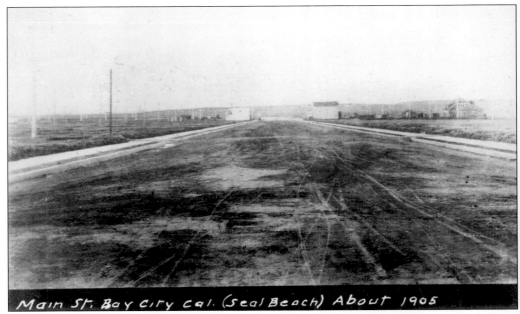

Main St. Bay City Cal. (Seal Beach) About 1905

This postcard shows Main Street, looking north to Marina Hill. The building on the left was on the southwest corner of Main Street and Electric Avenue; it was John C. Ord's general store. Across the street was the Labourdette Building. The two-story house on the right was the Proctor House, one of the earliest houses in Seal Beach. (Courtesy SBH&CS.)

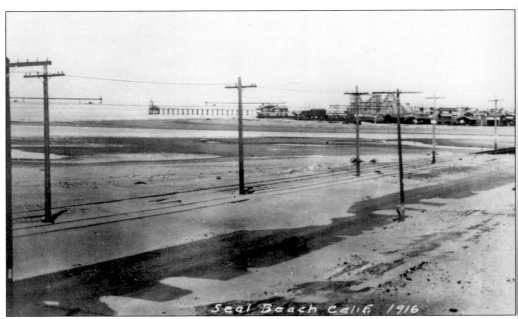

Seal Beach Calif. 1916

This 1916 postcard shows the Pacific Electric power poles and tracks leading to Anaheim Landing. The background shows the rollercoaster and pier. (Courtesy SBH&CS.)

This little house was one of many that were located on the beach near the pier in the early 1900s. They were moved in 1916 to make room for the Joy Zone. This little house is located on Twelfth Street. Barbara Rountree (shown here), a past president of the SBH&CS, worked to preserve this house. Originally painted green, it has weathered to light blue. (Courtesy SBH&CS.)

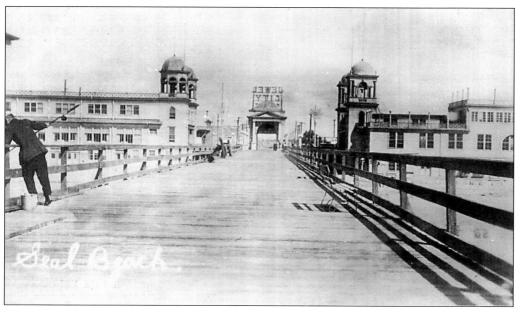

This view was taken from the pier and looks north toward the pier entrance and beyond to Main Street.

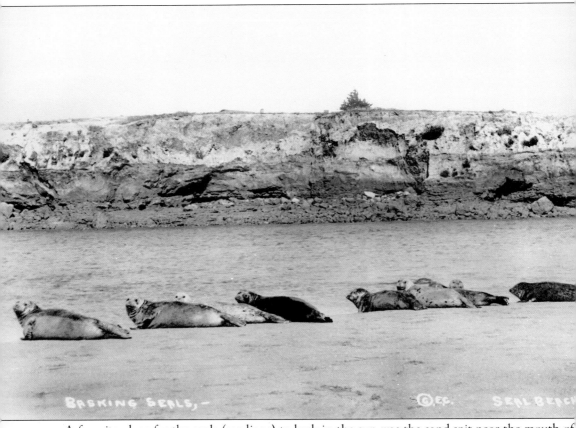

A favorite place for the seals (sea lions) to bask in the sun was the sand spit near the mouth of the San Gabriel River. With increased boating activity and people on the beach, the seals today remain farther out at sea. They can usually be seen around the Coast Guard buoys. (Courtesy First American Financial.)

Four

THE JOY ZONE

The Joy Zone was the amusement center started in 1916 in Seal Beach. Frank Burt had handled the concessions at the 1915 Panama-Pacific Exposition in San Francisco, which celebrated the opening of the Panama Canal. When Burt moved to Seal Beach, he formed the Jewel City Amusement Company and sold investment shares.

The Joy Zone featured a rollercoaster known as the Derby. It had been built for the exposition in San Francisco, was taken apart, and shipped to Seal Beach where it was reassembled.

Two pavilions stood at the entrance to the pier. The one on the west side housed the Jewel City Cafe, which could seat 500 people at a time. It also contained a bowling alley. The pavilion on the east side featured an 80- by 90-foot plunge, hundreds of changing rooms, and a dance floor.

Exhibitions by aerialist Joe Boquel and balloonist Wayne Abbott drew large crowds. Joe Boquel would skydive toward the beach, do loop-the-loops out over the water, and end in a fast dive straight at the beach. Wayne Abbott in his hot air balloon drifted over the ocean and jumped into the sea.

Many silent movies, such as Cecil B. DeMille's version of *The Ten Commandments* and Mack Sennet comedies, were filmed in Seal Beach. Among the film celebrities who visited or made movies here were Charlie Chaplin, Fatty Arbuckle, Wallace Reed, Mabel Normand, Douglas Fairbanks Sr., and Mary Pickford.

Beginning in 1929, the Great Depression gradually brought about the demise of the Joy Zone. With an unemployment rate of almost 25 percent, people could no longer spend money on amusements. The crowds of 20,000 visitors a week, who had been brought into the city by the Red Cars, no longer came to Seal Beach.

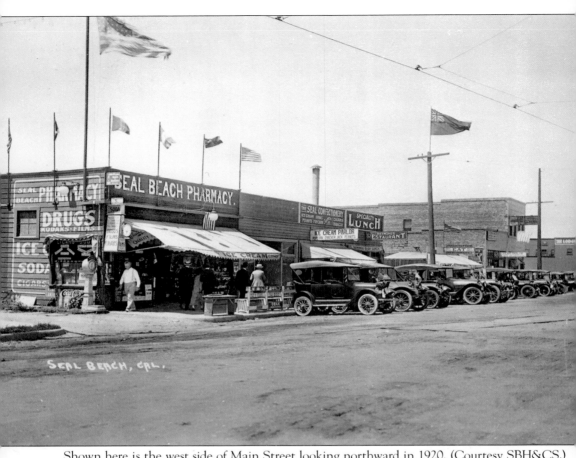

Shown here is the west side of Main Street looking northward in 1920. (Courtesy SBH&CS.)

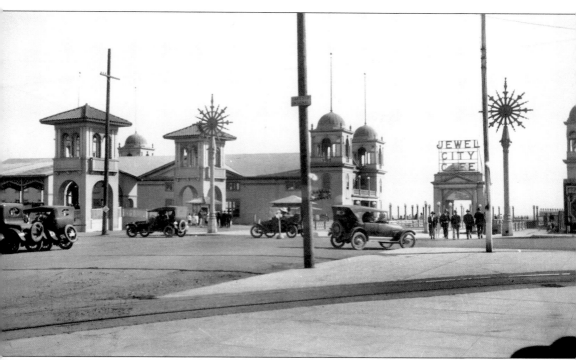

The entrance to the pier advertised the Jewel City Cafe, which is partially shown in the pavilion to the right in 1920. (Courtesy R.W. Whelan.)

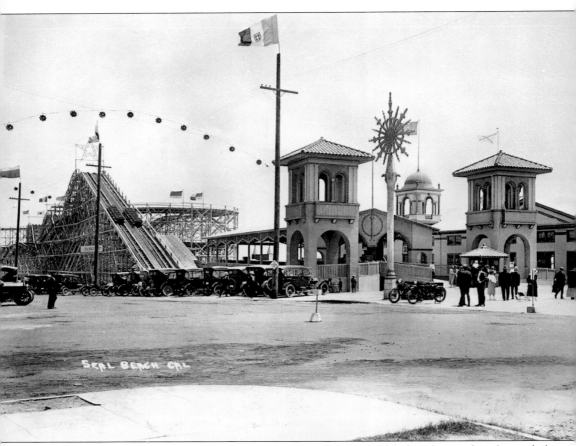

This view, taken from Ocean Avenue and Main Street, highlights the pavilion located closest to the rollercoaster. It featured an 80- by 90-foot plunge, changing rooms, and a dance floor. (Courtesy First American Title.)

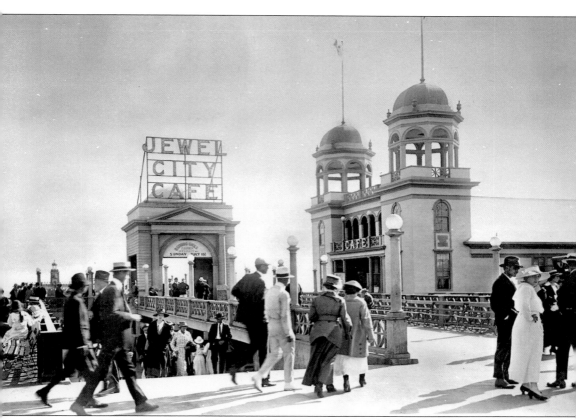

As many as 20,000 people a week visited the Joy Zone. In the foreground is the Ocean Avenue sidewalk leading to the entrance of the pavilions and pier in 1916. (Courtesy First American Title.)

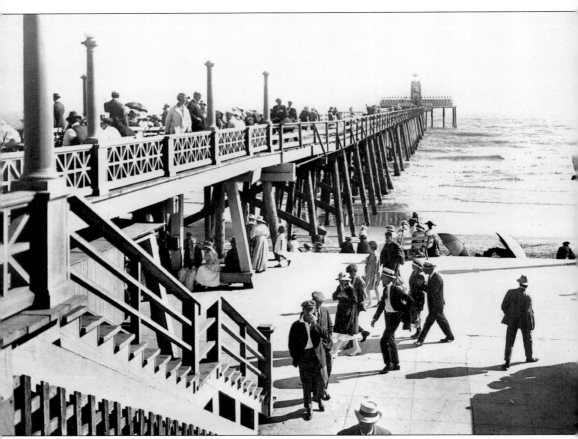

The pier was part of the Joy Zone—note the scintillator lights at the end of the pier. Built in 1915, this pier was to replace the original narrow pier that had been built in 1906. (Courtesy First American Financial.)

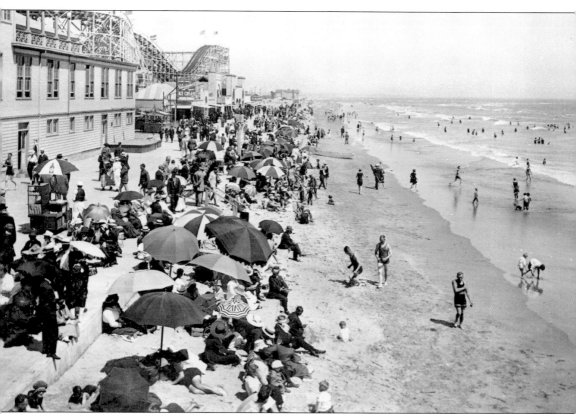

The pavilion shown here was on the east side of the pier and featured a plunge, three hundred changing rooms, and a dance floor. The arcade with shops and skills games is toward the center. A pushcart vendor can be seen toward the left. (Courtesy First American Title.)

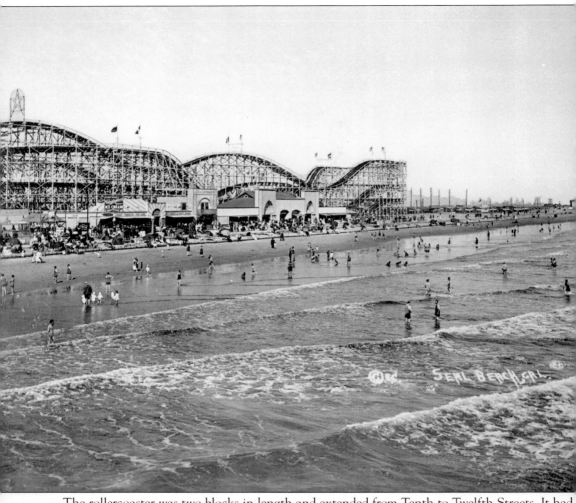

The rollercoaster was two blocks in length and extended from Tenth to Twelfth Streets. It had first been built for the Panama-Pacific Exposition in San Francisco. When it was reassembled in Seal Beach in 1916, it was known as the Derby. (Courtesy First American Title.)

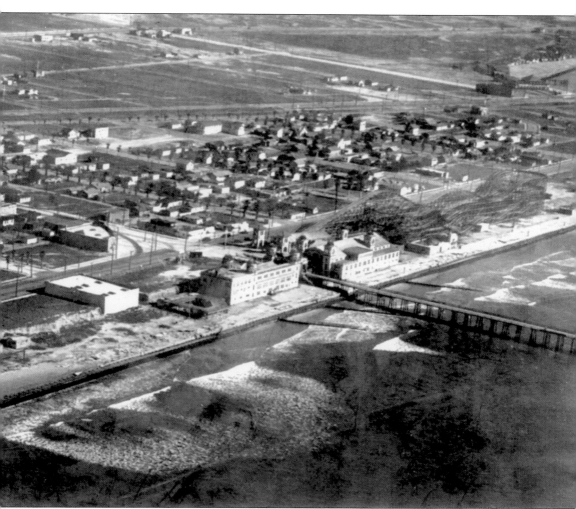

The enormity of the pavilions at the entrance to the pier is apparent in this 1927 aerial view. Looking to the left of the pier, note the semi-roofed structure by the pavilion. This was the garage for rental electric cars. The building to the far left was a candy factory. Looking to the right of the pier, the arcade can be seen at the beginning of the rollercoaster. (Courtesy SBH&CS.)

The Joy Zone featured games of skill as well as gift shops and food stalls in the arcade. The arcade was located between the beach and the rollercoaster. (Courtesy First American Financial.)

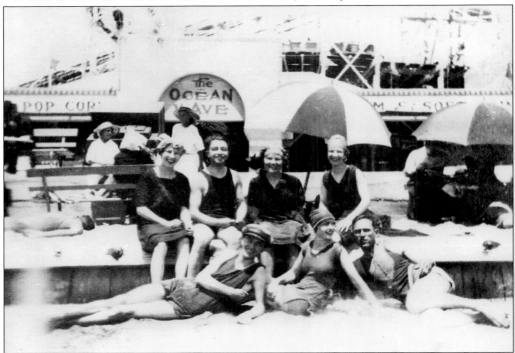

This happy group is enjoying the beach in 1917. The arcade of shops is behind them. (Courtesy SBH&CS.)

This 1917 picture shows Joe Boquel, a daredevil aerialist. He would sky-dive toward the beach, do loop-the-loops over the water, and end in a fast dive straight at the beach. His exhibitions drew large crowds. (Courtesy SBH&CS.)

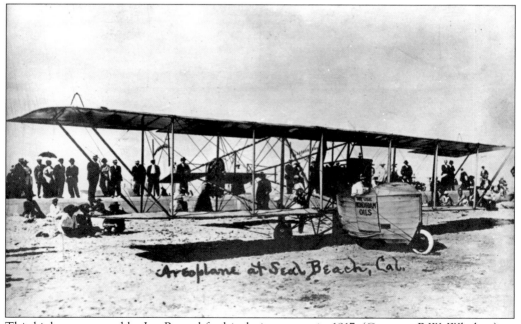

This biplane was used by Joe Boquel for his daring stunts in 1917. (Courtesy R.W. Whelan.)

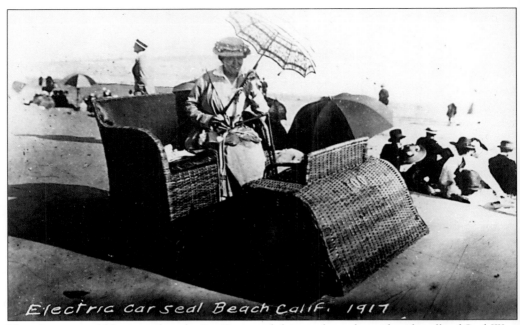

Electric cars could be rented at the Joy Zone and driven along the wide sidewalk of Seal Way. (Courtesy SBH&CS.)

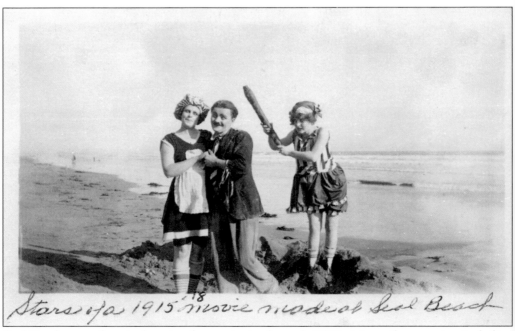

Seal Beach was a favorite location for movies in the early 1900s. Many silent movies, including Mack Sennet comedies, were filmed here. Charlie Chaplin and Fatty Arbuckle were in some of these films. (Courtesy SBH&CS.)

Five

THE PACIFIC ELECTRIC RED CARS

In the 1880s, Henry Huntington built and owned the Pacific Lighting Company which organized the network for his Pacific Electric Railway Company (Red Cars) which covered four counties.

In 1904, the electric Red Cars traveled a route from Los Angeles to Newport Beach. This line went through Long Beach, Seal Beach, Huntington Beach, and on to Newport. From 1913 until 1940, a second line (the Dinky Line) connected Seal Beach and Long Beach via Ocean Avenue and a trestle over Alamitos Bay. The trestle was parallel with the bridge that connected Seal Beach with Naples. The Dinky was a lightweight trolley.

In order to accommodate the thousands of people who wanted to visit Seal Beach and its Joy Zone, the Pacific Electric ran additional daily trips and sometimes hooked two or three Red Cars together. Extra tracks were laid for Red Cars that did not go on to Newport but waited until the visitors to the Joy Zone were ready to return home.

In 1913, tracks were installed from Electric Avenue to Ocean Avenue where a turnaround and train depot were located. The depot was located in the same building where the Bayside Land Company was.

Passenger Red Cars stopped traveling through Seal Beach in 1950. Freight Red Cars stopped in 1954. The railway right-of-way is now the Greenbelt. The Red Car Museum is located on what was once the route from Los Angeles to Newport Beach.

The Seal Beach Historical and Cultural Society chose the Red Car as a suitable museum to house artifacts and memorabilia because the Red Car had been so instrumental in the development of Seal Beach.

In November 1972, the SBH&CS bought a derelict Red Car without trucks (wheels) for $350. It had been a tower car, or rolling repair shop. A platform on the roof was raised to repair overhead electric lines. After several years of hard work by volunteers and much fundraising, the Red Car was restored and is a landmark and asset to the city.

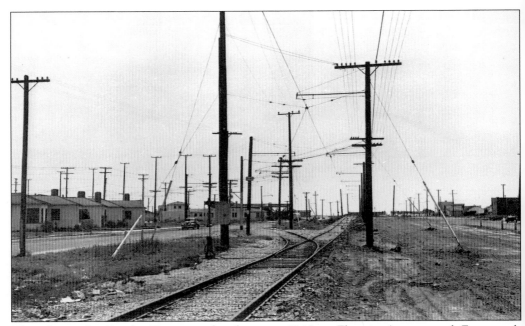

This shows the Pacific Electric right-of-way in 1946 at Electric Avenue and Fourteenth Street. The tracks curve to the left to go through the Navy base. Before the Navy base, the tracks went straight through to Anaheim Landing via a trestle located alongside a bridge. (Courtesy SBH&CS.)

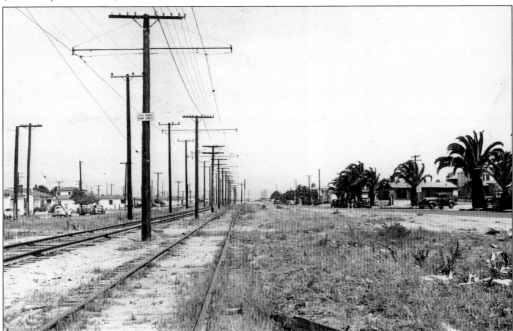

The Los Angeles–Newport Pacific Electric route had a right-of-way along Electric Avenue in Seal Beach. This picture shows the right-of-way looking east toward Main Street in 1946. (Courtesy SBH&CS.)

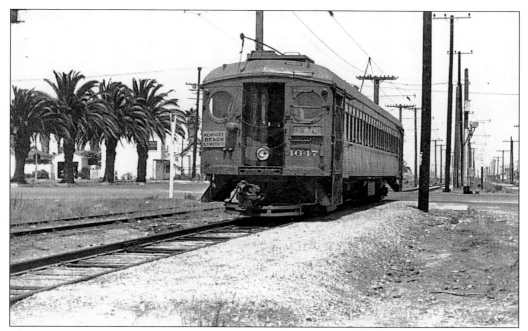

This Red Car is heading east to Newport Beach in 1946 after passing Main Street and Electric Avenue. Note the two-story building behind the palm trees. The Red Car Museum is located across the street from this residence. (Courtesy SBH&CS.)

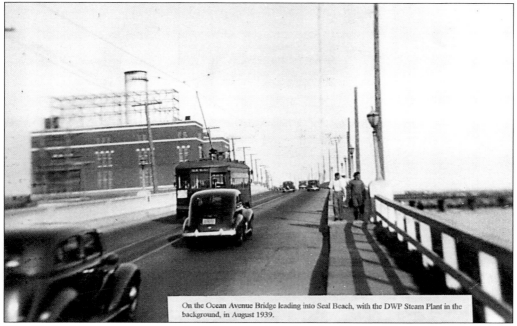

On the Ocean Avenue Bridge leading into Seal Beach, with the DWP Steam Plant in the background, in August 1939.

The Dinky Line was a separate line from the Los Angeles–Newport line. The Dinky Line traveled on a trestle that ran parallel with the bridge over the San Gabriel River and connected Seal Beach with Naples in Long Beach. This 1939 picture shows the steam plant of the Department of Water and Power (DWP) in the background. (Courtesy SBH&CS.)

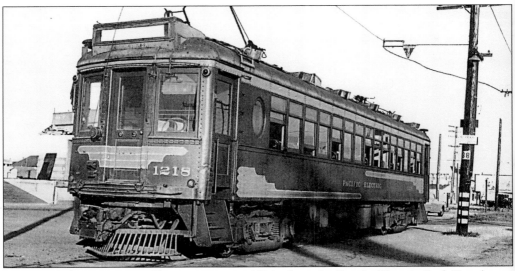

Seal Beach became accessible to visitors in 1904 when the Pacific Electric Red Cars began traveling through Seal Beach. The last passenger Red Car passed through Seal Beach in 1950; the last freight Red Car in 1954. (Courtesy SBH&CS.)

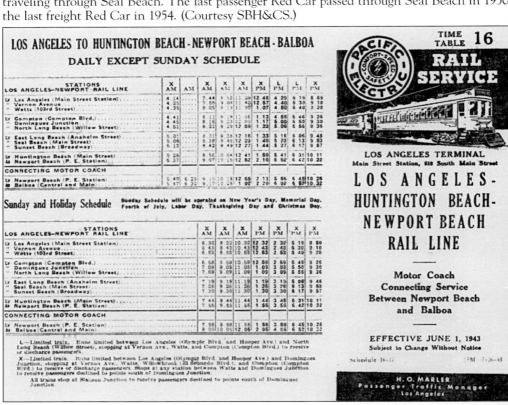

This 1943 rail schedule shows the runs from Los Angeles to Newport. During the Joy Zone period (1916–1930), the Pacific Electric ran additional cars, often two or three Red Cars hooked together. Any Red Cars not going on to Newport were stored on side tracks. (Courtesy SBH&CS.)

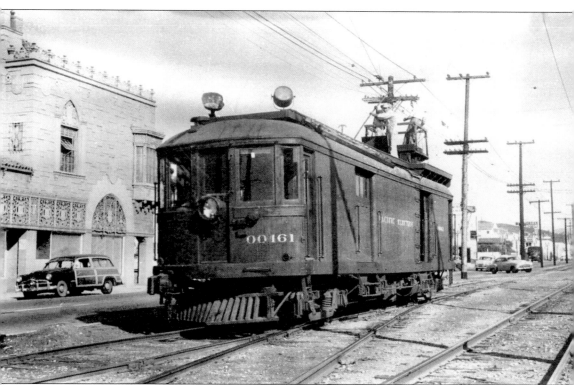

When the Seal Beach Historical and Cultural Society's Red Car Museum was in active service, it was a tower car, a rolling repair shop. It had a platform on the roof which could be raised to repair the overhead wires. This 1950 picture shows the Red Car on Santa Monica Boulevard in West Hollywood. This Red Car was in active service from 1925 until 1956. (Courtesy SBH&CS.)

With the demise of the Red Cars, a decision had to be made regarding the right-of-way. Some people suggested high rise apartments, but the people favoring a greenbelt with grass and trees won the argument. The Red Car Museum is located on the Greenbelt. (Courtesy SBH&CS.)

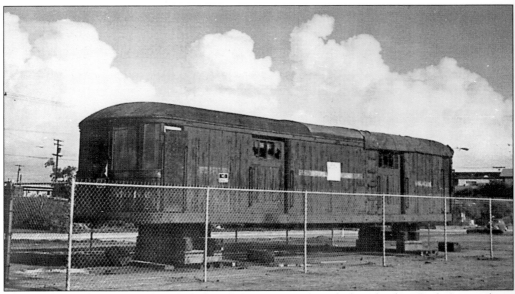

The Seal Beach Historical and Cultural Society purchased this derelict Red Car without trucks (wheels) in 1972. Restoration of its original beauty required years of volunteer labor and fundraising. (Courtesy SBH&CS.)

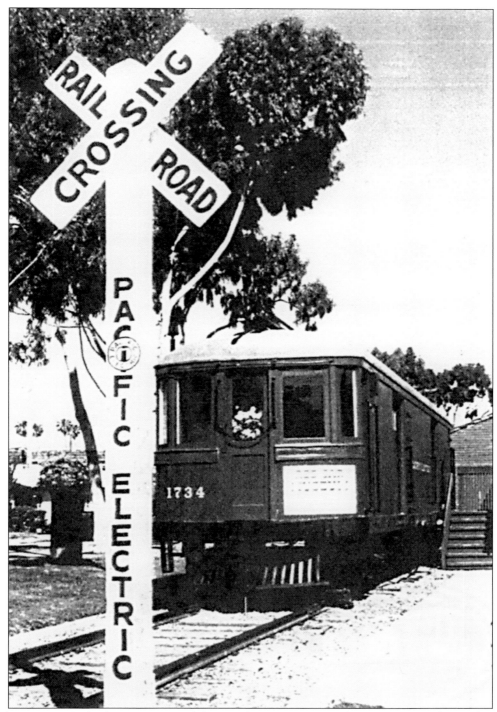

The SBH&CS displays its memorabilia, artifacts, pictures, and documents in the Red Car Museum. The purpose of the museum is for the public to enjoy and learn Seal Beach history. (Courtesy SBH&CS.)

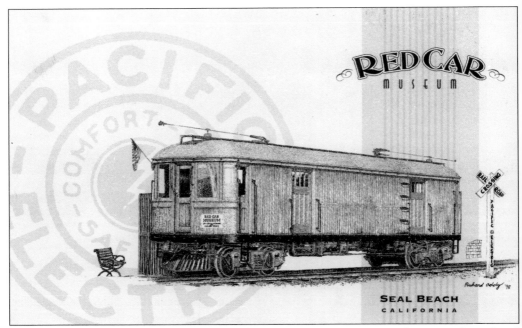

On August 27, 1999, the postal service unveiled its commemorative stamp honoring the railroad at Seal Beach in front of the Red Car Museum. This brought national attention to Seal Beach. The line drawing of the Red Car was made by Richard Addy. (Courtesy SBH&CS.)

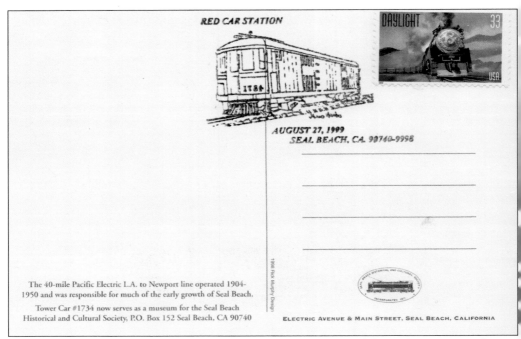

This is the other side of the postcard featuring the line drawing of the Red Car. Postcards were cancelled with a custom-made rubber stamp created by Gino Nardo. (Courtesy SBH&CS.)

Six

NAVAL WEAPONS STATION

In 1944, during World War II, the United States Navy purchased about 5,000 acres of land in Seal Beach. The Seal Beach Airport was part of the purchase. The airport was located on the land adjacent to the northeast corner of Bay Boulevard (now Seal Beach Boulevard) and Pacific Coast Highway. The acres also included Anaheim Landing. Many of the Anaheim Landing homes were moved to what is now known as Old Town. The Navy offered assistance in moving the homes.

The Navy holdings were known as the Naval Weapons and Ammunition and Net Depot (NAND). The channel in the bay was dredged to a 36-foot depth. NAND was able to handle large vessels such as destroyers, minesweepers, and aircraft carriers. The channel was also used by pleasure craft.

After the Korean War, the Navy entered a new era of weaponry. The age of guided missiles—launched from air, surface, sea, and under the sea—had arrived. In 1962, the secretary of the Navy designated that NAND be renamed Naval Weapons Station (NWS). Serious threats confronted the Navy though—the increase of private boats so close to stored ammunition and the proposals for a freeway to cross through the Station and over estuaries. Commanding Officer Captain F.F. Jewett II lent considerable influence toward solving the problems. As he pointed out, the NWS had proven to be an asset for Seal Beach in offering emergency assistance in boat and traffic mishaps, providing beach space for Scout campouts, participating in local activities, and providing a Color Guard for special occasions.

The NWS proposed a bypass channel and berm for protection of the increasing number of private boats. In return, the NWS would lease land to the county for an aquatic park at Sunset Beach. The problem of the proposed freeway ended when Captain Jewett, local citizens, and officials in Washington, D.C., lobbied for protection of the marshlands and the Wildlife Refuge came into existence.

A thousand acres of the Navy's land is set aside as a wildlife refuge to protect endangered species and salt marshes. More than 100 species of birds and over 50 species of fish have been identified. The marshes are also a feeding ground and resting place for migrating waterfowl.

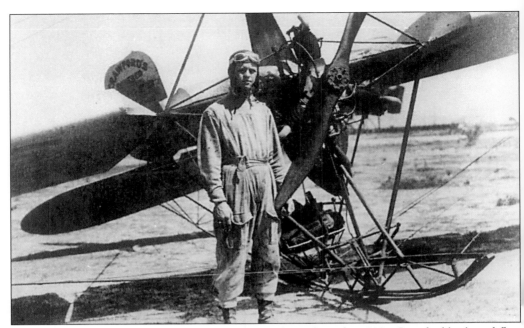

Crawford's Air Field was the original airport in Seal Beach in the 1920s. Crawford built and flew powered gliders. In the 1930s, the airport's name was changed to Seal Beach Airport. In 1943–1944, the U.S. Navy purchased the land where the airport was located. (Courtesy SBH&CS.)

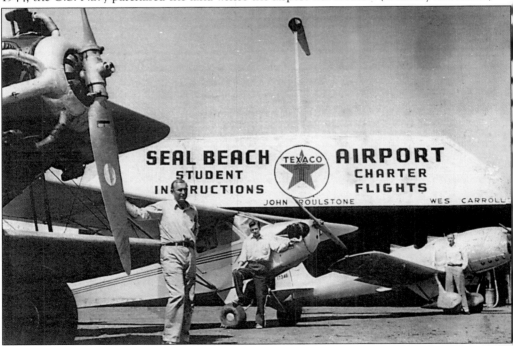

Wes Carroll (center) was a partner in the Seal Beach Airport. In 1939, he and another pilot, Clyde Schlieper, set a world endurance record of staying aloft for 30 days, a record that lasted for 25 years. (Courtesy SBH&CS.)

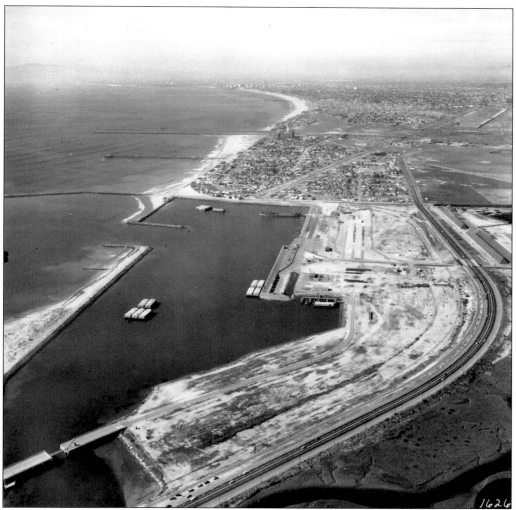

This 1954 aerial view of the Navy's harbor and dock also shows the pier (slightly above the center to the left) and the San Gabriel River channel beyond the pier. Pacific Coast Highway is shown curving along the right side down to the bottom center of the picture. (Courtesy SBH&CS.)

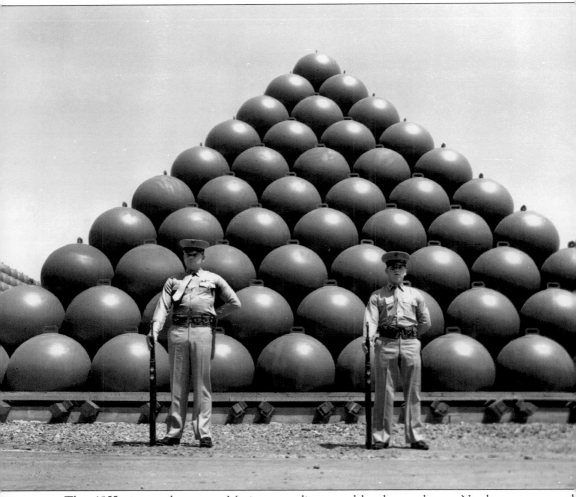

This 1955 picture shows two Marines standing guard by the net buoys. Net buoys were used during and after World War II to prevent unauthorized ships from entering the port. (Courtesy U.S. Navy.)

The Marines stationed at the Navy base have traditionally been helpful in community activities such as the annual Toys for Tots drive. (Courtesy SBH&CS.)

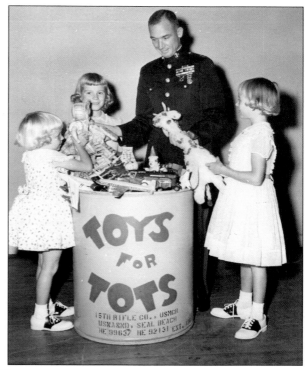

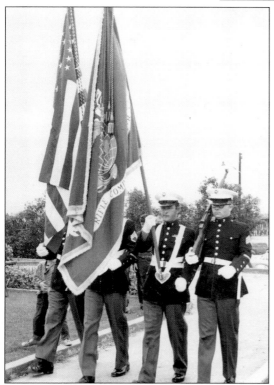

Upon request, the Marine Color Guard is available for special occasions and ceremonies as well as participating in the annual Memorial Day observance. (Courtesy SBH&CS.)

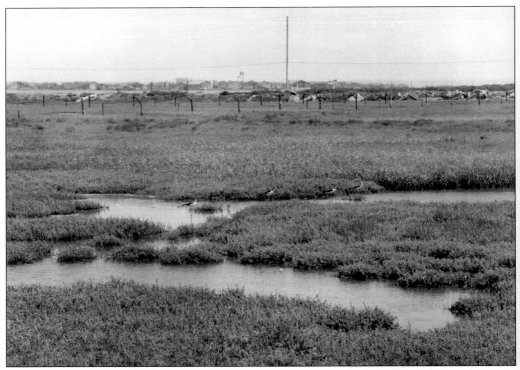

The Naval Weapons Station owns almost 5,000 acres of which 1,000 acres have been set aside as a National Wildlife Refuge. Over 50 species of fish and 100 species of birds have been identified at the refuge. (Courtesy U.S. Navy.)

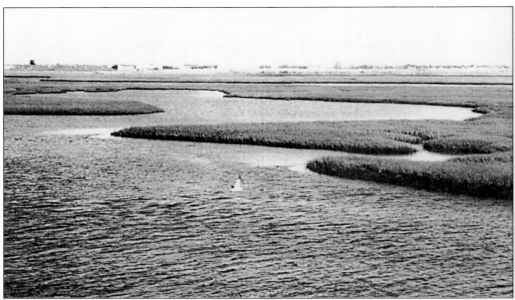

These wetlands are actually salt marshes. This wildlife refuge is a stopping place for migrating waterfowl. (Courtesy SBH&CS.)

Seven

EXPANSION OF SEAL BEACH

At one time, the trailer park was part of Old Town. Around 1930, Captain Grotemat bought a lease from the East Naples Land Company for 11 acres of land on First Street from Central Avenue to Marina Drive. He built a trailer park along Central Avenue and First Street.

When Captain Grotemat died, Bill Dawson bought the lease in 1974. With the cooperation of the Redevelopment Agency and the Coastal Commission, Dawson moved the trailer park northward to Marina Drive. This move made room for Dawson to build the Riverbeach condominiums at Central Avenue. The Seal Beach Trailer Park was the first trailer park in California to allow two-story cabanas and completely enclosed cabanas.

Building homes on Marina Hill (the "Hill") began in 1957. The developers purchased the land from the Hellman Ranch. Separate sections were built by different contractors. Marina Shores homes sold for $21,150 to $22,500. Lots averaging 60 feet wide were priced between $5,500 and $8,375.

After purchasing 541 acres from the Hellman Ranch, in 1962, Ross Cortese began building Leisure World: the first planned active retirement community of its kind in the United States. About 10,000 residents (one-third of the Seal Beach population) reside in Leisure World. They enjoy golf, shuffleboard, swimming, clubhouses, an amphitheater, and medical facilities.

Construction of College Park West began in 1964. The only entrance is over a bridge across the river on a street in Long Beach. The bike trail gives easy access to Cal State Long Beach. Edison Park, the largest park in Seal Beach, is located in College Park West. The park has room for baseball and soccer, as well as a track field.

College Park East covers nearly 800 acres. Construction began in 1965 and was completed by 1970. Housing includes both single family homes and condominiums. An active homeowners association publishes a newsletter and organizes parades and other special events.

In 1929, Surfside was the only gated, private beach resort along the coast. It grew into a closely knit group of people and became incorporated as Surfside Colony, Ltd., in 1930. In 1969, Surfside became part of Seal Beach. The Anaheim Bay breakwater, built for the Naval Weapons Station, prevented the natural circulation of sand, thus causing erosion. In 1982, an 800-foot revetment (rock seawall) was built for protection. Replenishing the sand is necessary about every five years.

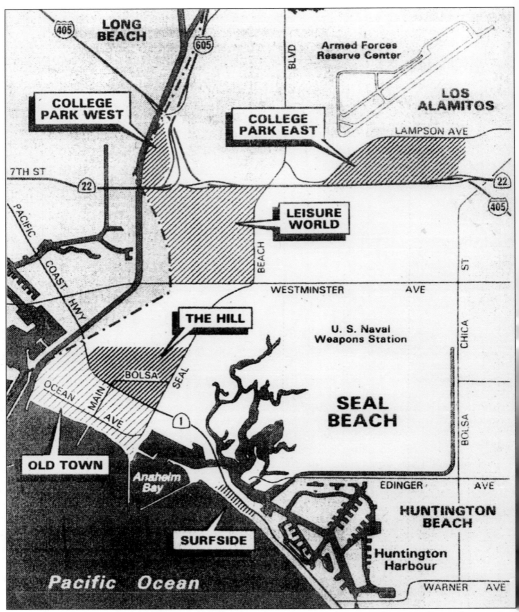

Major highways and a freeway divide Seal Beach into several areas. As a result, each area has developed its own traditions. (Courtesy *L.A. Times*.)

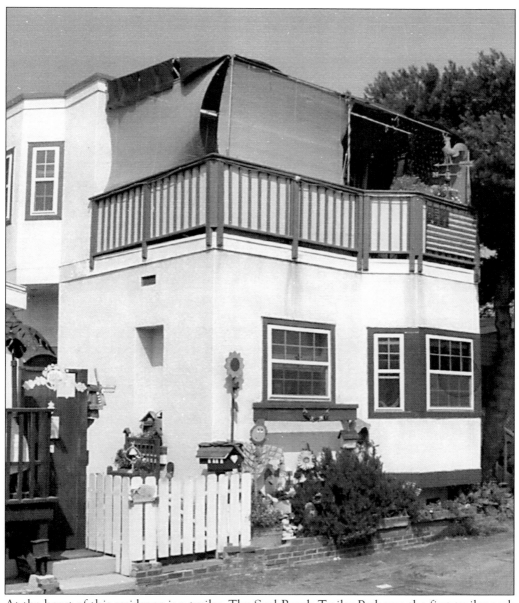

At the heart of this residence is a trailer. The Seal Beach Trailer Park was the first trailer park in California to allow two-story enclosed cabanas. (Courtesy Richard Whitehair.)

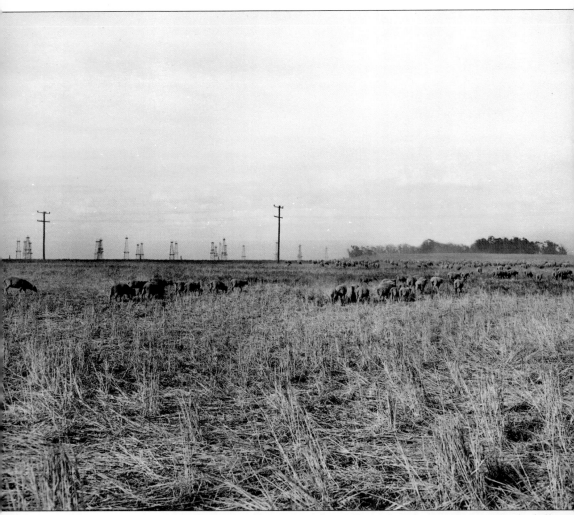

Sheep are grazing on the Marina Hill section of the Hellman Ranch in 1953. In 1957, the hill was subdivided and houses were built. The homes are said to be "on the Hill." (Courtesy SBH&CS.)

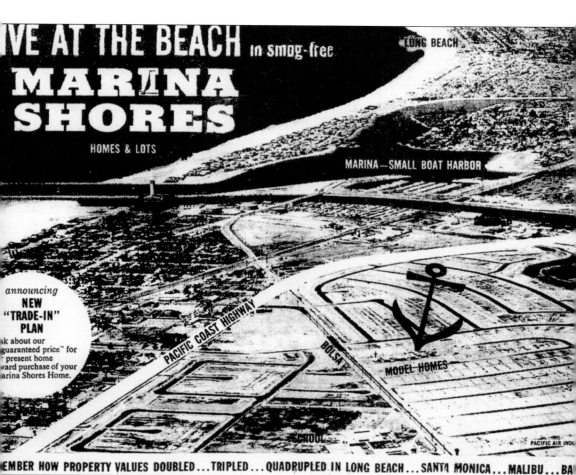

In 1957, Marina Hill was subdivided. Different contractors developed the housing. This advertisement shows the incentives to encourage purchase.

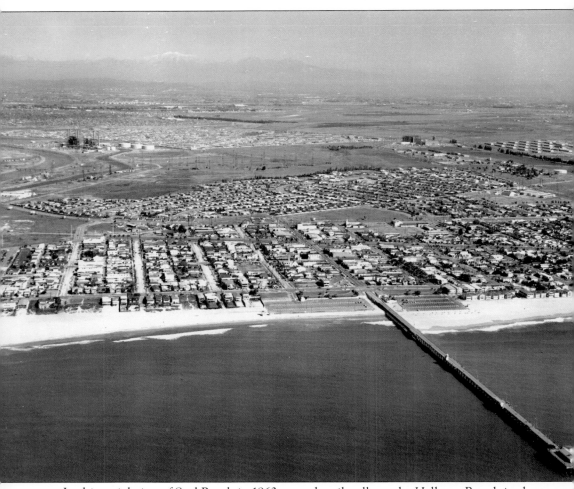

In this aerial view of Seal Beach in 1963, note the oil wells on the Hellman Ranch in the center of the picture. Beyond the oil wells is a triangular shape which is known as Leisure World. Below the oil wells is the housing built on Marina Hill. At the right is the Naval Weapons Station. (Courtesy R.W. Whelan.)

College Park West is another area of Seal Beach which is separated from much of Seal Beach by highways. College Park West has developed its own traditions as seen by this communal vegetable garden. (Courtesy Richard Whitehair.)

Edison Park, located in College Park West, is the largest park in Seal Beach. It has both a baseball diamond and soccer field as well as a track. (Courtesy Richard Whitehair.)

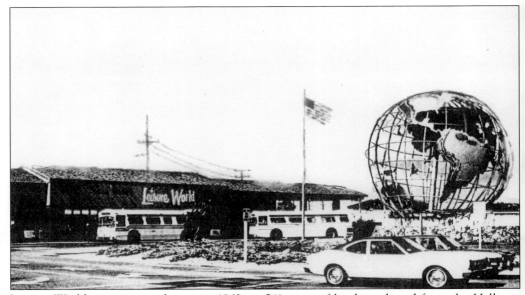

Leisure World construction began in 1962 on 541 acres of land purchased from the Hellman Ranch. It was the first planned active retirement complex of its kind in the United States. (Courtesy SBH&CS.)

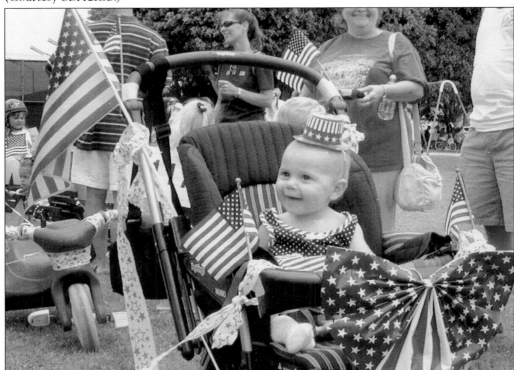

College Park East is separated from much of Seal Beach by highways and a freeway. The community has pride and spirit because of their interesting events, such as this Fourth of July parade. (Courtesy Richard Whitehair.)

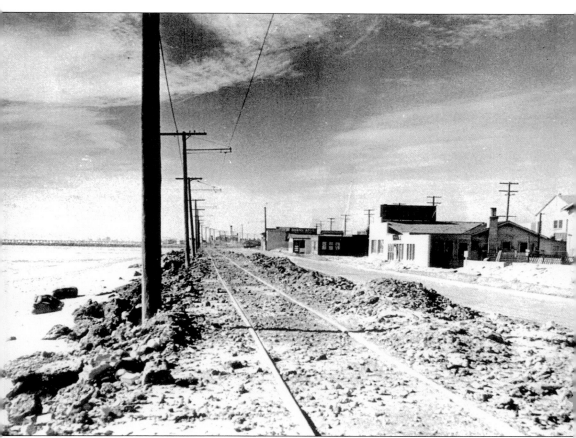

Surfside in the 1920s was the only gated, private coastal community in California. Note the Pacific Electric tracks which were north of Surfside. Surfside became part of Seal Beach in 1969. (Courtesy SBH&CS.)

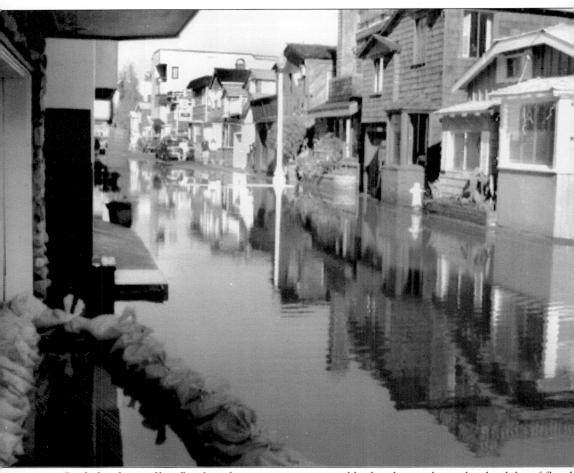

Surfside often suffers flooding from severe storms and high tides, as shown by this lake of flood water. The water has to be pumped out. Sandbags are placed before doors to avoid seepage into homes. (Courtesy of Richard Whitehair.)

Eight

THE PIER, BEACH, AND OCEAN

In 1906, a six-foot-wide Seal Beach pier with a length of 1,865 feet was built. It was known as the longest pier south of San Francisco.

In 1916, a new pier was built for the Joy Zone. During that era from 1916 until 1930, the public did not have access to the end of the pier because of high voltage. A 100-kilowatt generator powered 50 enormous lights which produced a combined 3,600,000 candlepower. Mounted on poles, the rainbow-colored lights could be turned in all directions and their light could be seen as far away as 20 miles. On weekends, the end of the pier was also used for setting off fireworks.

In 1935, waves from a summer hurricane that originated in the Philippines broke the pier in two. Because of the Great Depression, no money was available to make repairs until 1939.

In 1983, winter storms destroyed 120 feet of the pier. Grassroots fundraising by residents resulted in $130,000 toward repair costs. The remainder of the money needed was shared by the city, county, state, and federal governments and their entities.

The Seal Beach pier has always been a wooden structure. In repairing the 1983 damage, discussion arose over replacing the damaged sections with concrete. Residents, who consider part of the pier's charm to be its rustic appearance, successfully lobbied in stopping such plans. A short in the electric wiring under the pier resulted in severe fire damage in 1992. Another fire occurred when hot coals from a hibachi evidently lodged between the planks. Because of potential fire danger, the city council prohibited smoking on the pier.

Residents and visitors enjoy walking on this historic pier, pausing to watch the beachgoers, the children trying out the playground, the swimmers, and the surfers catching a wave. Fishermen can be seen reeling in a smelt, bass, tomcod, mackerel, and occasionally a halibut or corvina. At the end of the pier is Ruby's, with its 1940s decor. It is a popular place to rest and dine before enjoying the stroll back to Ocean Avenue.

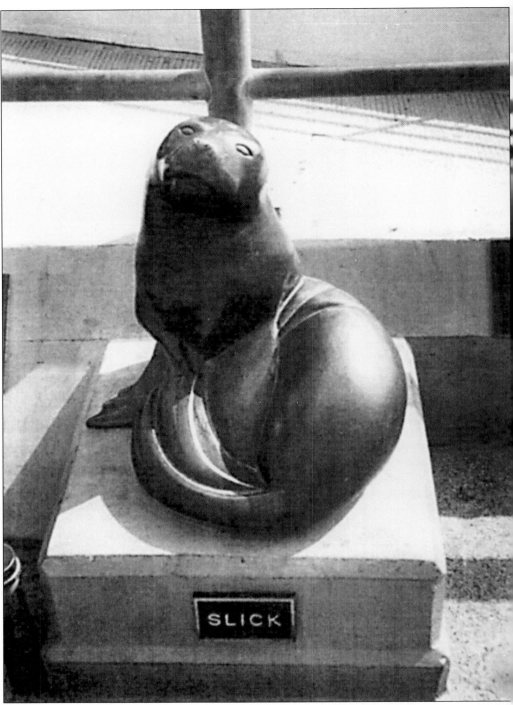

Slick is a bronze seal located at the entrance to the pier. When the pier was repaired after the disastrous storms of 1983, Slick the Seal took up residence and is a favorite of children. (Courtesy SBH&CS.)

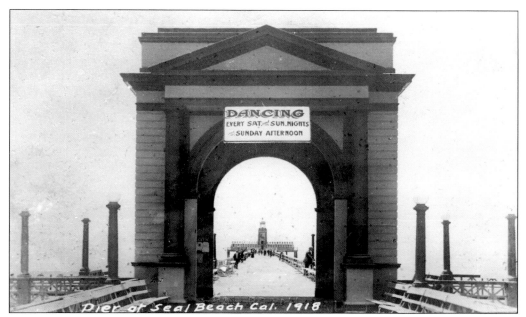

This 1918 postcard showed the entrance to the pier. The entrance framed the pier itself and showed the enormous scintillator lights located at the end of the pier. (Courtesy SBH&CS.)

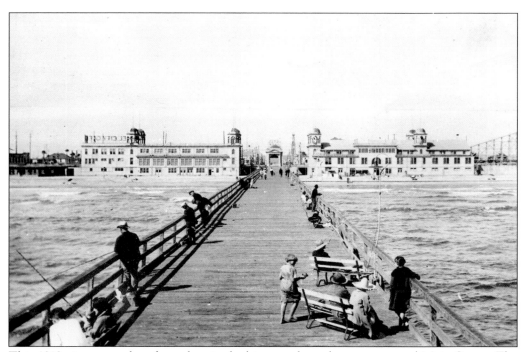

This 1918 view was taken from the pier looking north to the entrance and Main Street. The pavilion at the left housed the Jewel City Cafe and bowling alley. The pavilion at the right contained a plunge, changing rooms, and a dance floor. Note the rollercoaster at the far right. (Courtesy SBH&CS.)

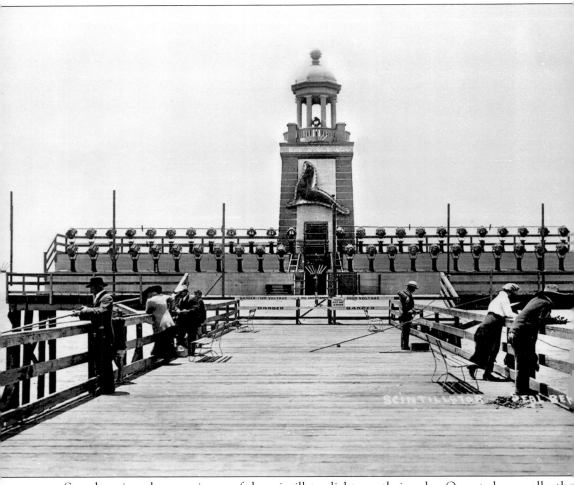

Seen here is a close-up picture of the scintillator lights on their poles. Operated manually, the lights could turn in any direction. The building featured a 100-kilowatt generator that could produce up to 3,600,000 candlepower. (Courtesy First American Title.)

Debris, including driftwood and logs, still accumulates along the shoreline. (Courtesy SBH&CS.)

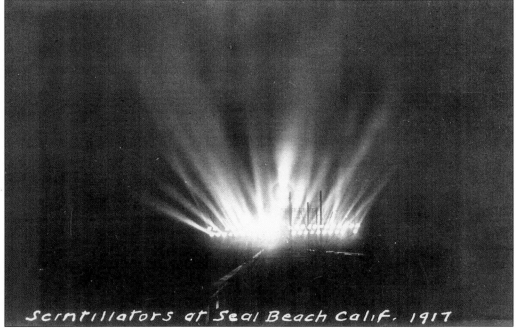

This 1917 postcard shows the enormous scintillator lights at the end of the pier. The glass was rainbow-colored which cast a beautiful light on the water. (Courtesy SBH&CS.)

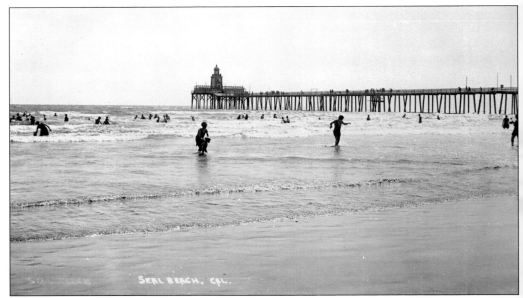

This 1920 picture shows the pier with its scintillator lights and the swimmers enjoying the water. Swimming was popular at night when the rainbow-colored lights lit up the water. Seal Beach was advertised as the beach without an undertow. (Courtesy First American Title.)

Attractive antique lampposts add to the charm of the pier. Esther, an oil island, can be seen to the left, barges are farther out, and Catalina can be seen on the horizon. (Courtesy Richard Whitehair.)

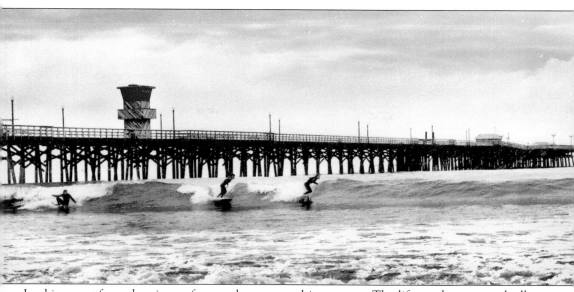

Looking west from the pier, surfers can be seen catching a wave. The lifeguard tower was badly gutted by fire from a short in the electric wires under the pier. The tower and several planks had to replaced. (Courtesy SBH&CS.)

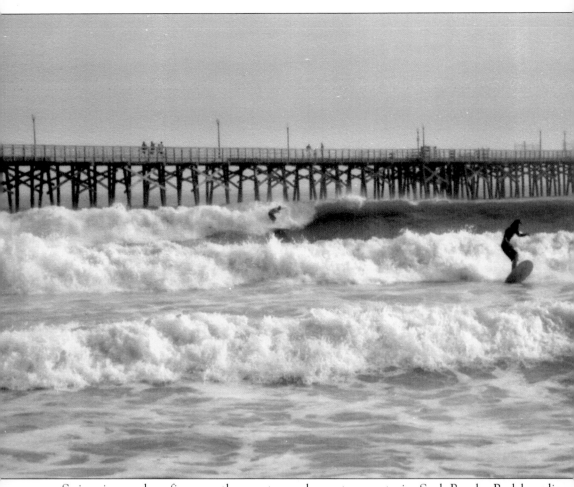

Swimming and surfing are the most popular water sports in Seal Beach. Bodyboarding, windsurfing, and parasailing are also enjoyed. (Courtesy Richard Whitehair.)

Earl Whittington was the first lifeguard in Seal Beach and began his career at Anaheim Landing. Whittington was dedicated to teaching children how to swim and conducted classes for this purpose. (Courtesy SBH&CS.)

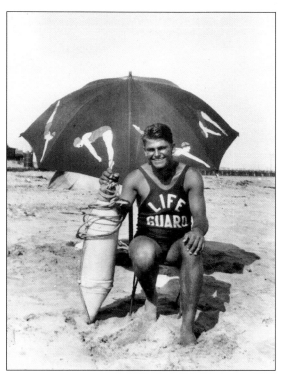

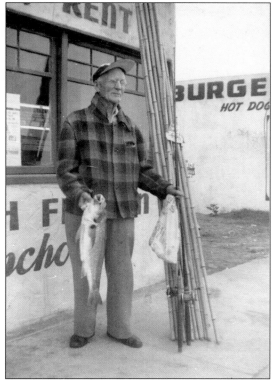

Fishing from the pier, this skilled angler reeled in a 7½-pound spotfin croaker. (Courtesy SBH&CS.)

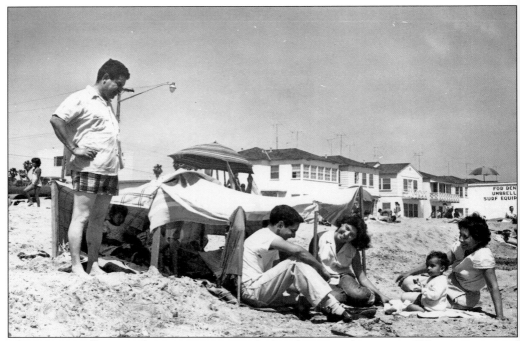

The visitors walking on the pier enjoy seeing the beachgoers and swimmers. The apartments in the background are located on Seal Way. (Courtesy SBH&CS.)

The children's playground is located on the sand east of the pier. The children enjoy slides, swings, and a jungle gym. (Courtesy SBH&CS.)

Winter storms, especially if they are combined with high tides, can flood Seal Way. Each winter a berm of sand is built as a means of protection, although the berm can be breached by ocean waves. Some of the people who live on Seal Way keep sandbags on hand for extra protection. (Courtesy SBH&CS.)

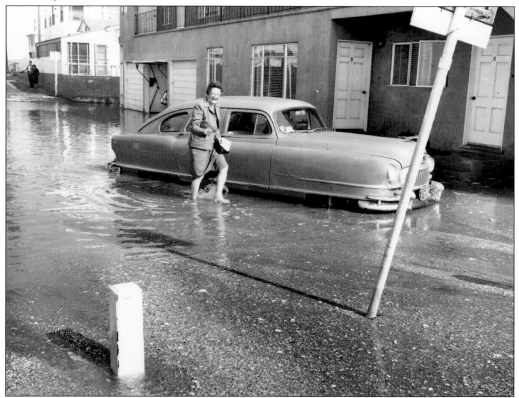

Flooding along Seal Way can be severe and occasionally water enters low-lying cross streets. When that happens, the water travels along the side streets and goes as far as two blocks to Electric Avenue. (Courtesy SBH&CS.)

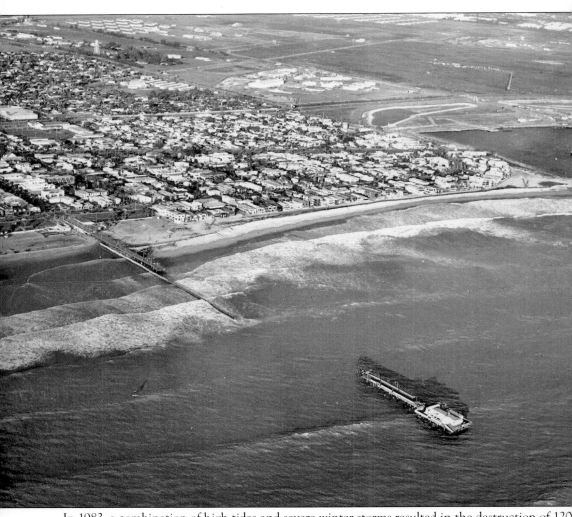

In 1983, a combination of high tides and severe winter storms resulted in the destruction of 120 feet of the pier. The apartments along Seal Way suffered flooding with water entering under doorways. (Courtesy R.W. Whelan.)

Nine

HERE AND THERE

In this chapter, important and interesting places and events will be featured which do not fit in with the themes of previous chapters. For example, gambling began in Seal Beach in the 1920s with roulette, bingo, card games, craps, and slot machines.

In the early 1930s, Tony Cornero launched a fleet of gambling ships anchored off Santa Monica, just outside the three-mile limit. The ships traveled down the coast and gamblers were ferried to the ships by speedboats. In 1939, Cornero's ships were shut down by court orders to stop the taxi service. In 1946, Cornero reopened shipboard gambling with the Lux, which was anchored off Seal Beach. Following another legal battle, Cornero was forced to give up his ship.

In 1950, William Robertson's Airport Club was the first legal gambling casino in the Long Beach–Orange County area. Residents who opposed Robertson and believed he wielded influence over the City Council formed activist groups. After numerous recall elections of city council members and several lawsuits, legal gambling operations stopped by 1954.

Another important feature of Seal Beach history was North American-Rockwell purchasing the Number 1 Home Ranch of the Hellman property. The corporation eventually became Rockwell International and is now Boeing. Rockwell contracted with NASA to build the Saturn Booster Stage which launched the Apollo spacecraft resulting in the first men on the moon in 1969. In July 1971, astronauts Dave Scott (Commander), Alfred Warden, and James Irwin visited the facility. Seal Beach honored them with plaques and medals identifying them as reserve police officers of Seal Beach.

Pictured here in 1917 are Seal Beach Boy Scouts Don and Harold Barnes. (Courtesy SBH&CS.)

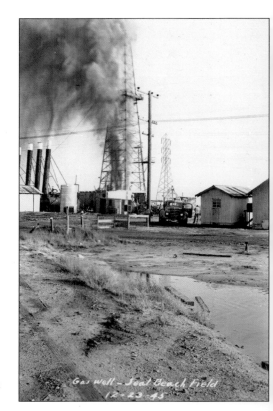

The Seal Beach oil field was located between the San Gabriel River and First Street. This 1945 picture shows a well which produced natural gas. (Courtesy SBH&CS.)

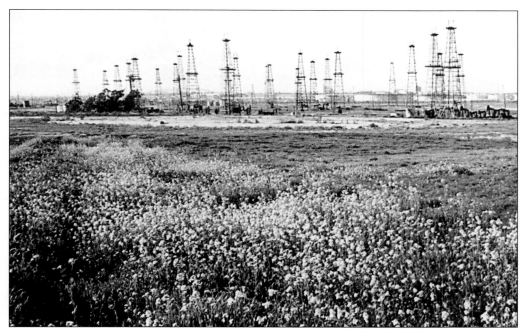

Seen here are the oil wells located on the Hellman Ranch. (Courtesy SBH&CS.)

The house of Judge John C. Ord is located on the northeast corner of Central Avenue and Tenth Street. It was built in 1923 and is still in use. (Courtesy SBH&CS.)

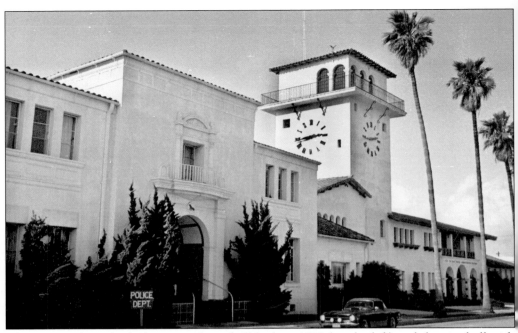

This picture shows both the original city hall built in 1929 (on the left) and the city hall with the clock tower built in 1969. The police department, which was part of the original city hall, is now located in its own facility on Seal Beach Boulevard. (Courtesy SBH&CS.)

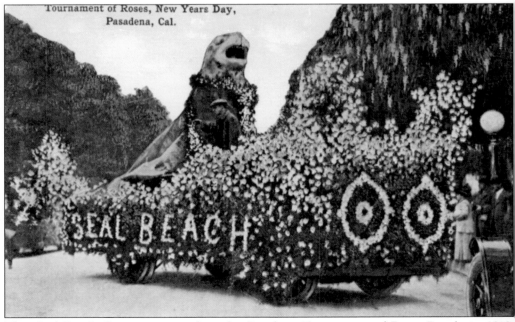

Tournament of Roses, New Years Day, Pasadena, Cal.

SEAL BEACH

This Seal Beach float was entered in the Pasadena Tournament of Roses Parade in 1918. (Courtesy SBH&CS.)

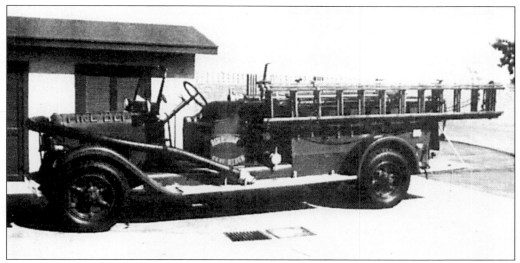

For many years, this La France fire engine served Seal Beach, Surfside, and Sunset Beach. Fire Chief Sperry Knighton directed the all-volunteer firemen. The La France still appears in parades. (Courtesy SBH&CS.)

When he began his medical practice in 1939, Dr. Homer De Sadeleer was the only doctor in Seal Beach. With his compassion for the elderly and infirm, he made house calls throughout his 50 years of practice. (Courtesy SBH&CS.)

Organized in 1923, the Woman's Club is the oldest service organization in Seal Beach. They take an active part in assisting with community events and raise funds to aid worthy nonprofit groups. Shown here is the Woman's Club Chorus in the 1950s. These ladies certainly know how to have a good time! (Courtesy SBH&CS.)

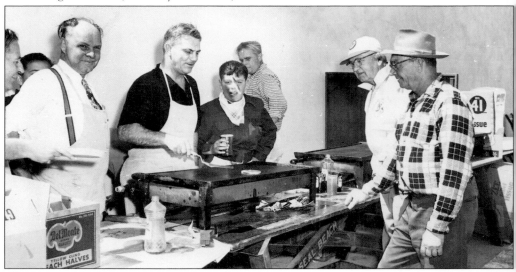

The Lions Club, formed in 1939, is one of the oldest service organizations in Seal Beach. Their fundraising efforts help support an eye clinic and other worthy projects. An annual pancake breakfast (shown here) and fish fry are the chief means of raising funds. (Courtesy SBH&CS.)

84

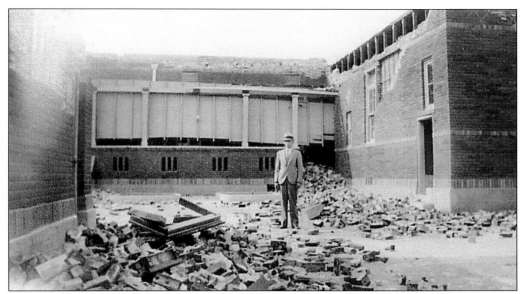

Superintendent and principal J.H. McGaugh surveys the damage to the Seal Beach Elementary School, caused by the 1933 Long Beach earthquake. The fallen bricks were salvaged and used to build a wall around the school. (Courtesy SBH&CS.)

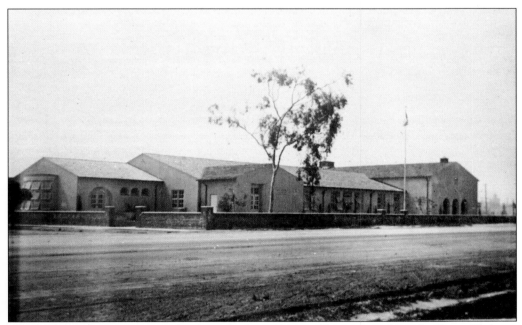

The Seal Beach Elementary School was built in 1914 on the corner of Pacific Coast Highway and Twelfth Street. This picture shows how the school looked in 1935 after being repaired from the 1933 earthquake. The school's name was later changed to Mary Zoeter Elementary School in honor of a longtime school board member. (Courtesy SBH&CS.)

The Parks and Recreation Department keeps the schedule for the many activities and events in Seal Beach. Local schools are generous in allowing use of their facilities by the public. (Courtesy SBH&CS.)

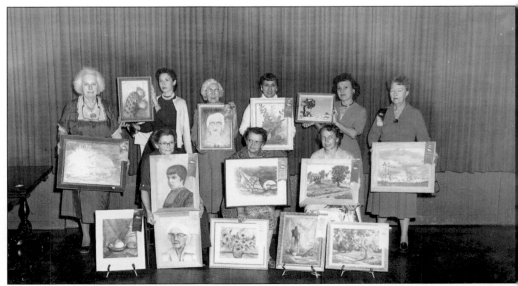

As is true of most coastal communities, Seal Beach has an Artists League. (Courtesy SBH&CS.)

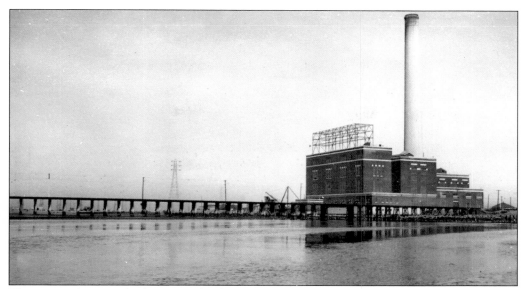

The steam plant was built in 1922 by the Los Angeles Gas and Electric Company. It was sold in 1939 to the Los Angeles Department of Water and Power (DWP). This plant furnished the electricity that was used in building the Hoover (Boulder) Dam. During the 1933 earthquake, the smoke stack was knocked down and later rebuilt to half its original height. (Courtesy Jean B. Dorr.)

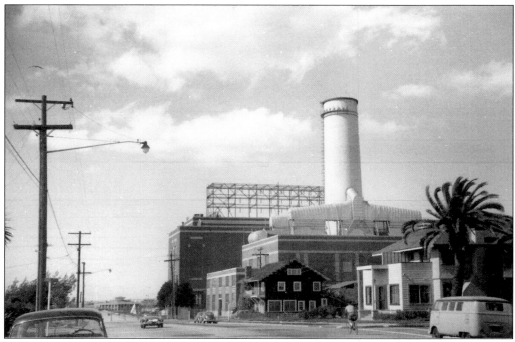

Here is another view of the DWP steam plant in 1967. The two-story house near the plant was the home of Philip A. Stanton, the "father" of Seal Beach. (Courtesy SBH&CS.)

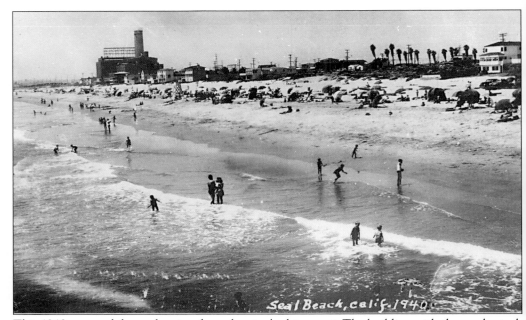

This 1940 postcard shows the view from the pier looking west. The building with the smokestack was the Department of Water and Power (DWP) steam plant. Prior to the 1933 earthquake, the smokestack was twice as high. (Courtesy SBH&CS.)

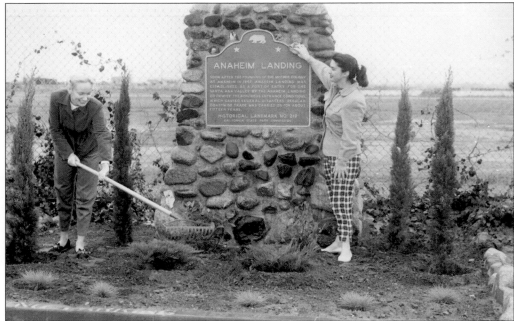

The California State Park Commission issued Historical Landmark No. 219 for Anaheim Landing which states: "Soon after the founding of the mother colony at Anaheim in 1857, Anaheim Landing was established as a port of entry for the Santa Ana Valley by the Anaheim Landing Co. despite treacherous entrance disasters. Regular coast-wise trade was carried on for about 15 years." (Courtesy SBH&CS.)

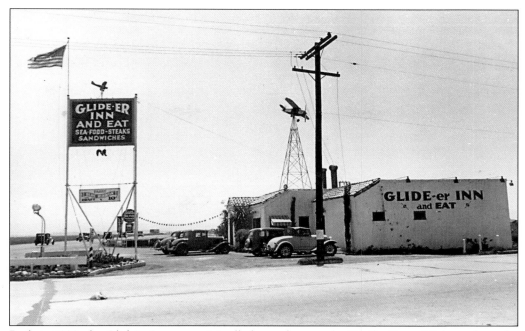

Built in 1930, the Glide'er Inn was originally located across the Pacific Coast Highway from the Seal Beach Airport. Its distinctive roof with a small plane on the tower made it an interesting landmark. The inn also kept a logbook signed by pilots. Charles A. Lindbergh and Amelia Earhart both signed the logbook. (Courtesy SBH&CS.)

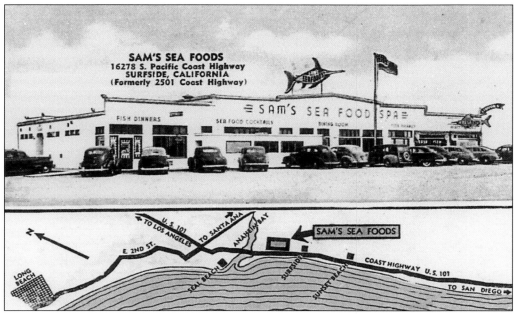

Sam's Seafood has been a popular restaurant and fish market for many years. This postcard is from the 1940s. (Courtesy SBH&CS.)

Lux, a gambling ship, was anchored off Seal Beach from 1946 to 1947. Speedboats took the gamblers to the ship. The ship was closed down by a state judicial ruling. (Courtesy SBH&CS.)

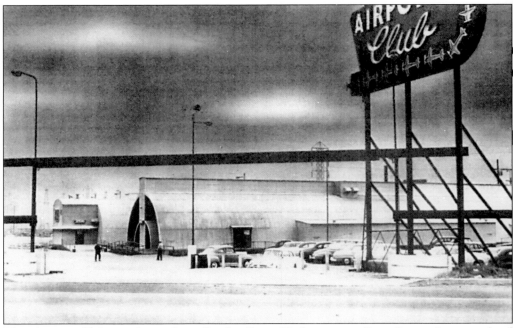

The Airport Club was located on Pacific Coast Highway near First Street. It was a legal gambling casino from 1950 to 1954. Later, it was used as a dance hall for teenagers and was known as the Marina Palace. (Courtesy SBH&CS.)

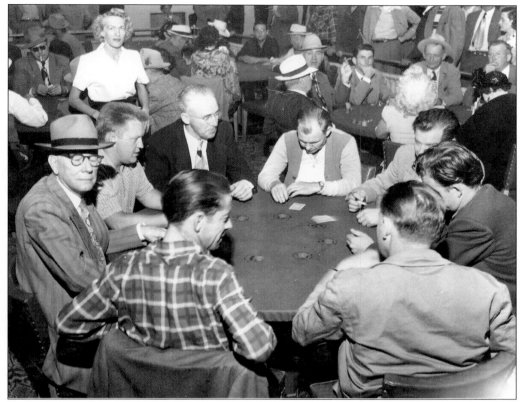

The Airport Club, which opened in 1950, featured draw poker. It was the only legal gambling casino in the Long Beach–Orange County area. Family-oriented groups felt the owner, William Robertson, was unduly influencing the city council. They used recalls and lawsuits to successfully end the club. (Courtesy Long Beach Independent.)

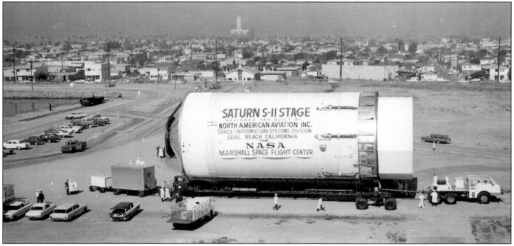

North American-Rockwell in Seal Beach contracted with NASA to build the Saturn Booster Stage which launched the first men to the moon in 1969. The property is now owned by Boeing. (Courtesy North American-Rockwell.)

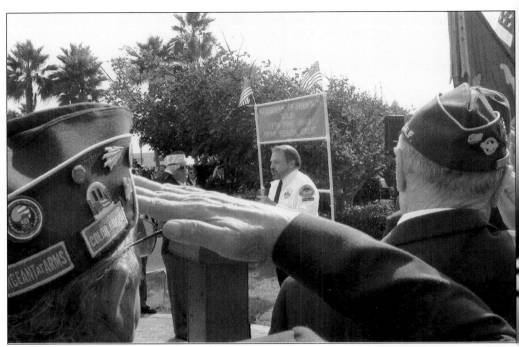

The Veterans of Foreign Wars and the American Legion sponsor the annual Memorial Day observance which is a solemn, yet inspirational event. (Courtesy Richard Whitehair.)

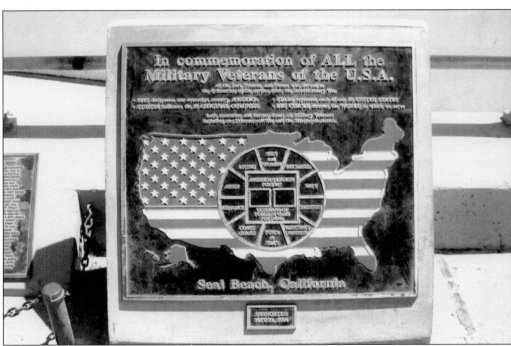

Part of Eisenhower Park is dedicated to veterans. This latest plaque honors veterans of all wars. (Courtesy Richard Whitehair.)

Santa visits Seal Beach while a volunteer with the police department looks on. Many retired people volunteer with the police which gives the department a high profile of visibility and helps account for the low crime rate. (Courtesy Richard Whitehair.)

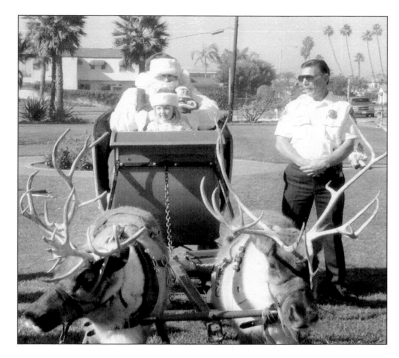

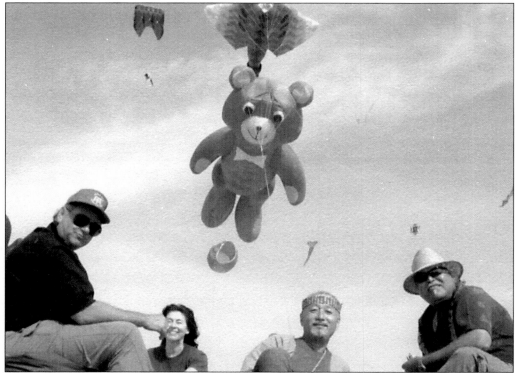

Kite flying is the focus of a popular annual contest. The kites are colorful and unusual, and professional kite fliers from Japan are featured. (Courtesy Richard Whitehair.)

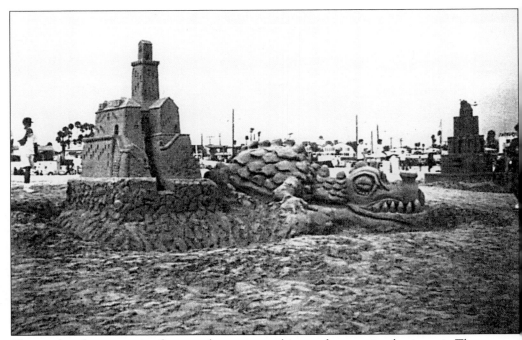

The sandcastle contest is often one between employees of competing businesses. The contest brings in thousands of visitors. (Courtesy SBH&CS.)

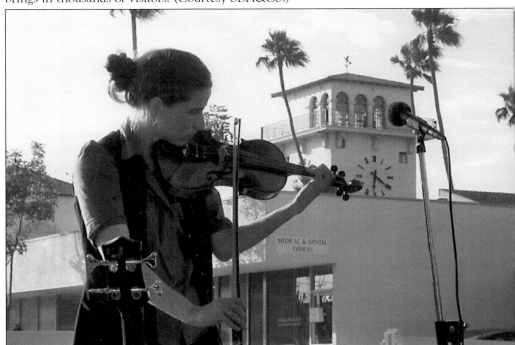

The chamber of commerce sponsors music on Wednesday evenings in the summer. Originally the event was held on Main Street but is now held at Eisenhower Park. Families enjoy picnicking on the grass and listening to the music. (Courtesy Richard Whitehair.)

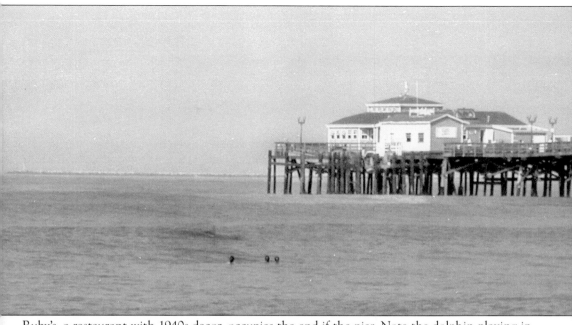

Ruby's, a restaurant with 1940s decor, occupies the end if the pier. Note the dolphin playing in the water beyond the three swimmers. (Courtesy Richard Whitehair.)

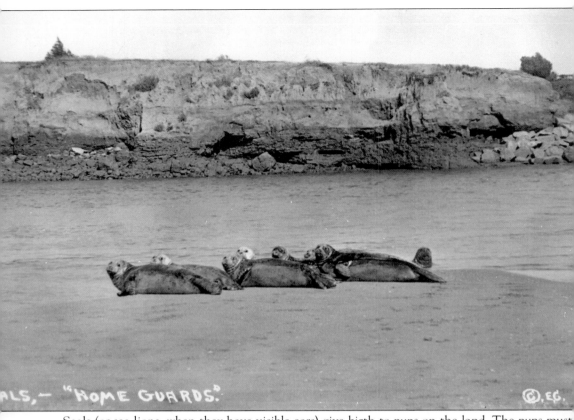

ALS, — "HOME GUARDS." (C).EG.

Seals (or sea lions, when they have visible ears) give birth to pups on the land. The pups must be taught how to swim. (Courtesy First American Title.)

Ten

PHOTO GALLERY

For over 30 years, the Seal Beach Historical and Cultural Society has received a multitude of pictures from the early 1900s. Unfortunately, identifying information was only provided with a few of these.

In tribute to these people who lived, worked, and played in Seal Beach, we are taking their pictures out of the file case so that once more they come to life on the pages of this book.

In 1971, a small group of Seal Beach residents met to discuss the passing of generations past. The decision was made to form the Seal Beach Historical and Cultural Society (SBH&CS), a nonprofit organization, to collect and preserve memorabilia and encourage good citizenship and participation in civic affairs. Jean B. Dorr, a founding member, began interviewing longtime residents and sifting through records at city hall. Her research over several years resulted in the book *A Story of Seal Beach*.

The townspeople answered the historical society's request for documents, pictures, and other memorabilia. These donations would be preserved and displayed for the education and enjoyment of others. Extensive archives were developed, and a museum in the Red Car was created for the display of those treasures from the archives.

The importance and value of the SBH&CS can clearly be seen in this book. Without the archives and museum, this book would not have been possible. For this reason, all royalties from book sales will go directly to the SBH&CS.

As this pictorial history of Seal Beach comes to a close, these words of wisdom come to mind: "We struggle on because every town, no matter how small, should have a place to preserve memories and memorabilia. For if the people do not care about the past, there is no pride in the present or concern for the future."

The bluff, rocks, and sand spit identify the location of this picture as the mouth of the San Gabriel River. (Courtesy SBH&CS.)

The rockiness indicates the area between Anaheim Landing and Seal Beach. (Courtesy SBH&CS.)

The relatively quiet water indicates this picture was taken at Anaheim Bay. (Courtesy SBH&CS.)

A group of lovely ladies graces the beach. (Courtesy SBH&CS.)

Anaheim Bay was ideal for children because the waves were gentle. (Courtesy SBH&CS.)

This happy swimmer was evidently in Anaheim Bay. The buoy line was typical of the bay (Courtesy SBH&CS.)

These happy girls are garbed in beachwear typical of 1915. (Courtesy SBH&CS.)

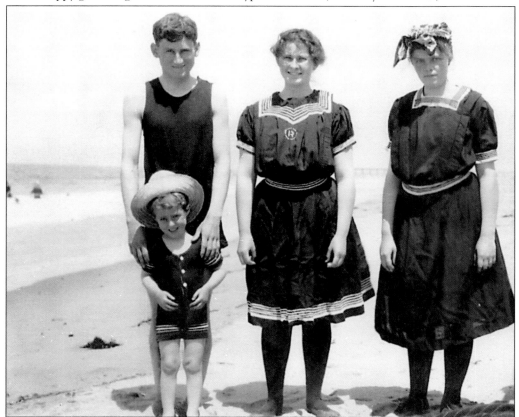

This happy group is outfitted in their 1920s swimwear. (Courtesy SBH&CS.)

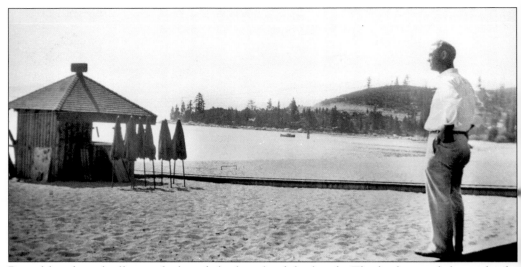

Rental beach umbrella stands dotted the length of the beach. The background shows the far side of Anaheim Landing. (Courtesy SBH&CS.)

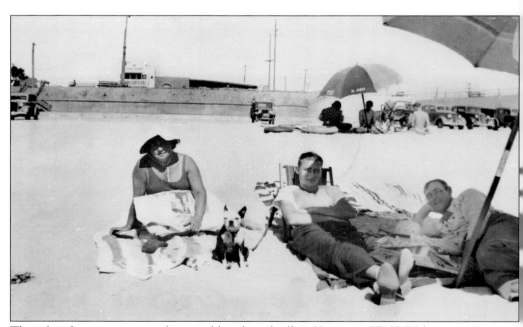

These beachgoers are using the rental beach umbrellas. (Courtesy SBH&CS.)

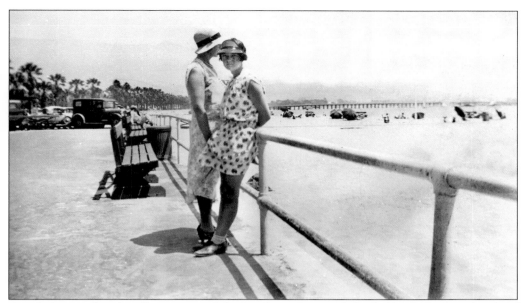

A mile-long wide sidewalk was part of the Joy Zone. It extended a half-mile from each side of the pier. (Courtesy SBH&CS.)

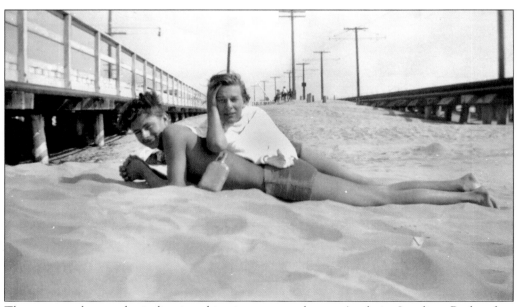

The power poles are the indication this picture was taken at Anaheim Landing. Both a foot bridge and railroad trestle connected the landing with Seal Beach. (Courtesy SBH&CS.)

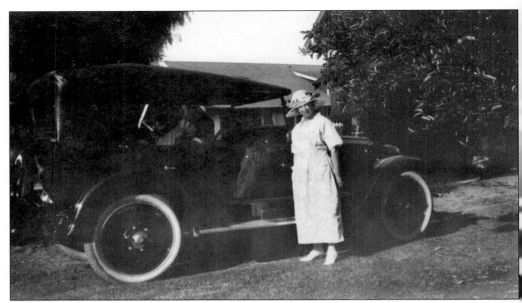

Henry Ford made the automobile more affordable; however, very few people owned cars. The vehicle shown in this picture was in the "touring class." The fortunate families who could afford a touring car spent Sunday afternoon visiting and exploring other places. (Courtesy SBH&CS.)

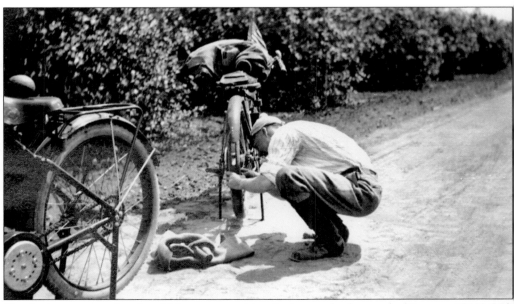

Bicycle tires punctured easily, which meant repairing the inner tube frequently. (Courtesy SBH&CS.)

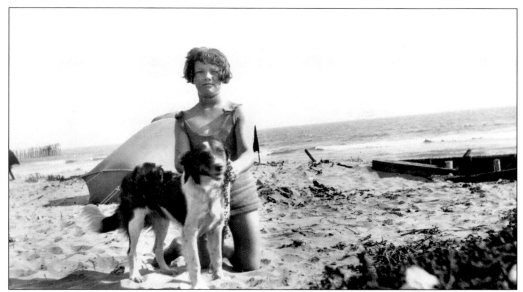

This lucky dog enjoys a sunny day at the beach. Today, dogs are no longer welcome on the beach. (Courtesy SBH&CS.)

Then, as well as now, young children like to dig in the sand. (Courtesy SBH&CS.)

This was evidently a game of leapfrog. One of the pavilions at the pier flanks the background. (Courtesy SBH&CS.)

Evidently, this steep incline required teamwork to mount. This picture was taken at Anaheim Landing as indicated by the power poles. (Courtesy SBH&CS.)

Seal Beach sponsored an annual bathing suit fashion parade. (Courtesy SBH&CS.)

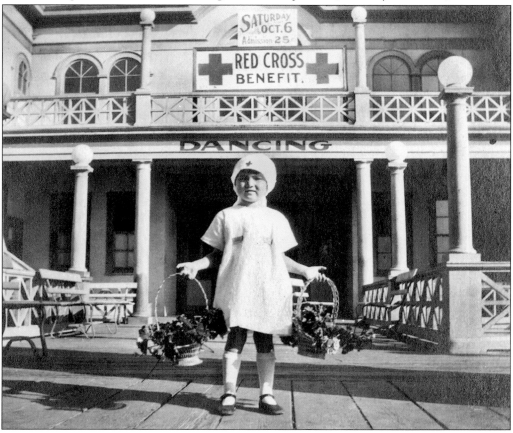

Helen Ely Trausur is shown at a Red Cross benefit on October 6, 1917. She is the flower girl. (Courtesy SBH&CS.)

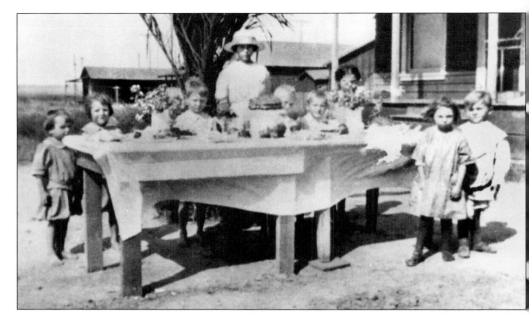

These young children were probably attending a birthday party. Notice the cake on a stand in the middle of the table. (Courtesy SBH&CS.)

A favorite place for friends to gather was the beach along the rollercoaster. This picture was probably taken in the late 1920s. (Courtesy SBH&CS.)

The resemblance of members of this group seems to indicate several generations of a family. (Courtesy SBH&CS.)

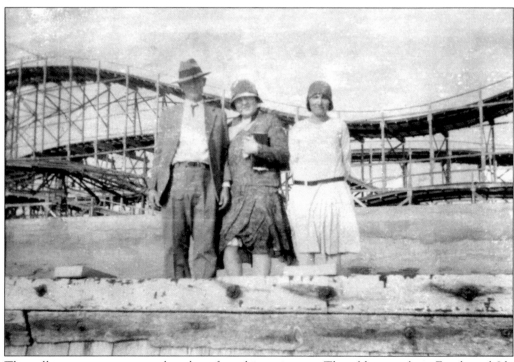

The rollercoaster was a popular place for taking pictures. The older couple is Frank and Ida Osterman. The younger woman is not identified. (Courtesy SBH&CS.)

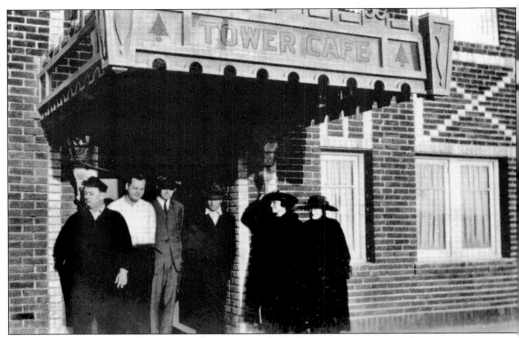

The Tower Cafe was a popular restaurant on Main Street. After a riot in July 1922, it was never the same. Later it became Pappy Perry. (Courtesy SBH&CS.)

This happy family is enjoying a tea break. The rollercoaster can be seen in the background. (Courtesy SBH&CS.)

This young girl displays her ability to perform a headstand. (Courtesy SBH&CS.)

This happy girl, with her bucket, is standing behind seaweed. (Courtesy SBH&CS.)

Under the watchful eye of their mother, these children are enjoying digging and playing in the sand. (Courtesy SBH&CS.)

The man in the picture does not seem to be very happy. Is it perhaps because he is partially buried in the sand? (Courtesy SBH&CS.)

This girl enjoys the ride on her inflatable float. (Courtesy SBH&CS.)

This ecstatic lady shows her enthusiasm for the surf. (Courtesy SBH&CS.)

This winsome girl is enjoying the beach in 1918. (Courtesy SBH&CS.)

These young men are evidently enjoying using construction material at a site located across the street from the Tower Cafe on Main Street. (Courtesy SBH&CS.)

According to the information on the back of this 1930 photo, the lady pictured was the police matron. (Courtesy SBH&CS.)

The man standing on the pier was Carl Randall, the Seal Beach mail carrier, who took mail to and from the "mail run" Red Cars. (Courtesy SBH&CS.)

This threesome is enjoying their ride in a rowboat at Anaheim Landing. (Courtesy SBH&CS.)

This family is trudging homeward after time spent on the beach. Note the power poles in the photo that indicate this is Anaheim Landing. (Courtesy SBH&CS.)

This fashionable family looks charming. (Courtesy SBH&CS.)

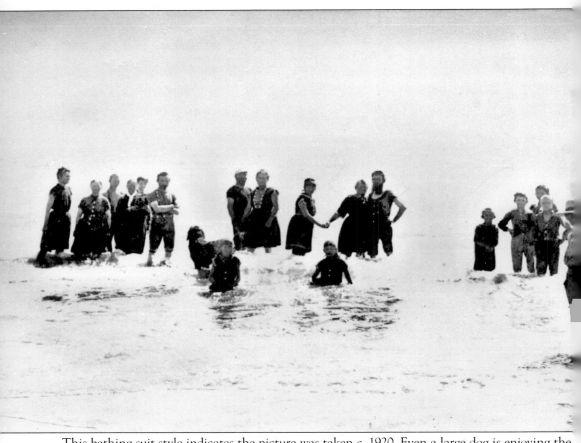

This bathing suit style indicates the picture was taken *c.* 1920. Even a large dog is enjoying the water. (Courtesy SBH&CS.)

Another happy group is enjoying the beach. The style of bathing suits can be dated to the 1930s. (Courtesy SBH&CS.)

Dan Sanchez donated this July 7, 1924 photo of his mother, Josephine Rendon Sanchez. She was 15. (Courtesy SBH&CS.)

The handsome man at Anaheim Landing in 1935 is Ned Whittington. Ned was the older brother of Earl Whittington, who became the first Seal Beach lifeguard. Both Ned and Earl served as lifeguards at Anaheim Landing. (Courtesy SBH&CS.)

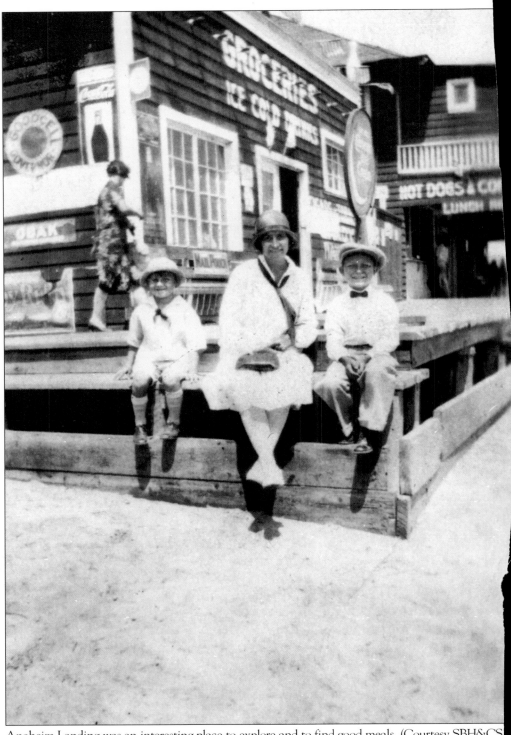

Anaheim Landing was an interesting place to explore and to find good meals. (Courtesy SBH&CS

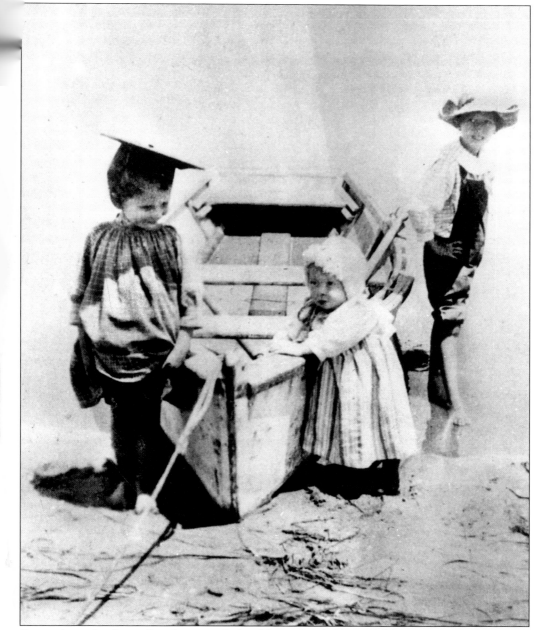

Pictured at Anaheim Landing are Judge Howard's children Adele, Jimmie, and Horace. (Courtesy SBH&CS.)

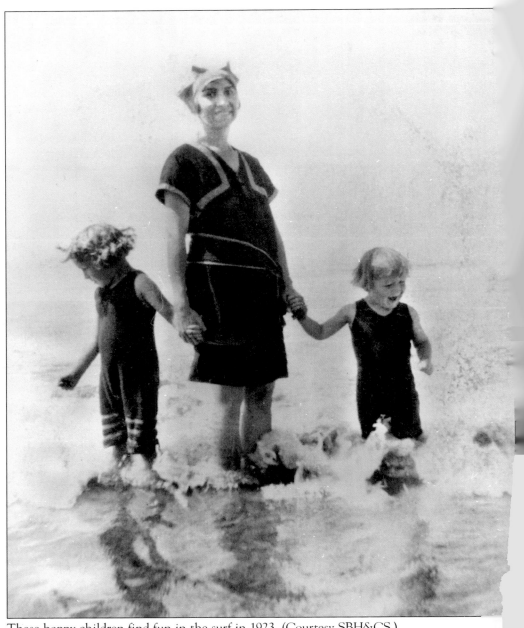

These happy children find fun in the surf in 1923. (Courtesy SBH&CS.)

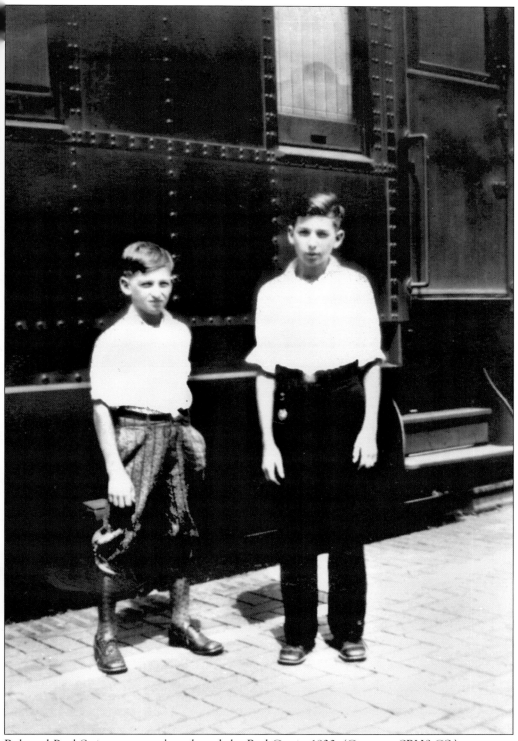

Bob and Paul Swigart are ready to board the Red Car in 1930. (Courtesy SBH&CS.)

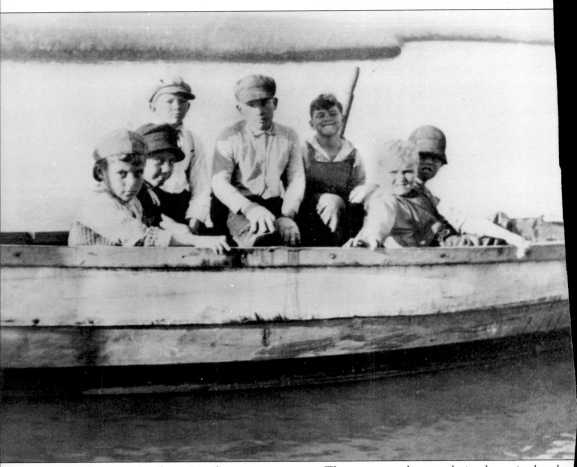

Rowboats at Anaheim Landing were common. They were used not only in the quiet bay but also to travel the inlets to what is now the National Wildlife Refuge. Clams and mussels could be found along the inlets. (Courtesy SBH&CS.)